Simcoe Ontario in Colour Photos, Saving Our History One Photo at a Time

Photography
by Barbara Raué
2013

Series Name:
Cruising Ontario

Book 37: Simcoe

Cover photo: Reflections on the water – 40 Wilson Avenue, Simcoe Composite School

Series Name: Cruising Ontario

Now in colour

Book 33: Southampton
Book 34: Jarvis
Book 35: Hagersville
Book 37: Simcoe
Book 38: Cambridge Part 1 – Galt Book 1
Book 39: Cambridge Part 1 – Galt Book 2
Book 40: Cambridge Part 2 – Preston
Book 41: Cambridge Part 3 – Hespeler
Book 42: Kitchener Book 1
Book 43: Kitchener Book 2
Book 50: Orangeville Beginnings
Book 51: Orangeville on Broadway

Other Books by Barbara Raue

Coins of Gold

Arrows, Indians and Love

The Life and Times of Barbara
Volume 1: Inventions That Have Enhanced My Life
Volume 2: Entertainment That I Have Enjoyed
Volume 3: East Coast Trips
Volume 4: Olympics Have Always Intrigued Me
Volume 5: Wonders of the World
Volume 6: Caribbean Cruises We Have Enjoyed
Volume 7: Animals
Volume 8: Storms and Other Major Disasters in My Lifetime
Volume 9: Wars, Terrorist Attacks and Major Disasters

The Cromwell Family Book

Visit Barbara's website to view all of her books
http://barbararaue.ericraue.com

Simcoe

Simcoe is a town in Southwestern Ontario located near Lake Erie at the junction of Highways 3 and 24, south of Brantford. From Hamilton take Highway 6 to Simcoe.

Simcoe was founded in 1795 by Lieutenant-Governor John Graves Simcoe. He gave a grant to Aaron Culver, one of the earliest settlers, with the condition that he was to build mills. In 1801 he built a sawmill and a few years later added a grist mill. The combined operation known as Union Mill was instrumental in the development of Simcoe. By 1812 a hamlet had grown up around the mills. The mills were burnt and the adjacent houses looted by U.S. troops in 1814. In 1819-23, Culver laid out a village which he called Simcoe. The mill was rebuilt by Duncan Campbell around 1825. By the 1870s, Nathan Ford operated a large flour mill, grain elevator and distillery on this site. The last water-powered mill on this site ceased operations in 1928.

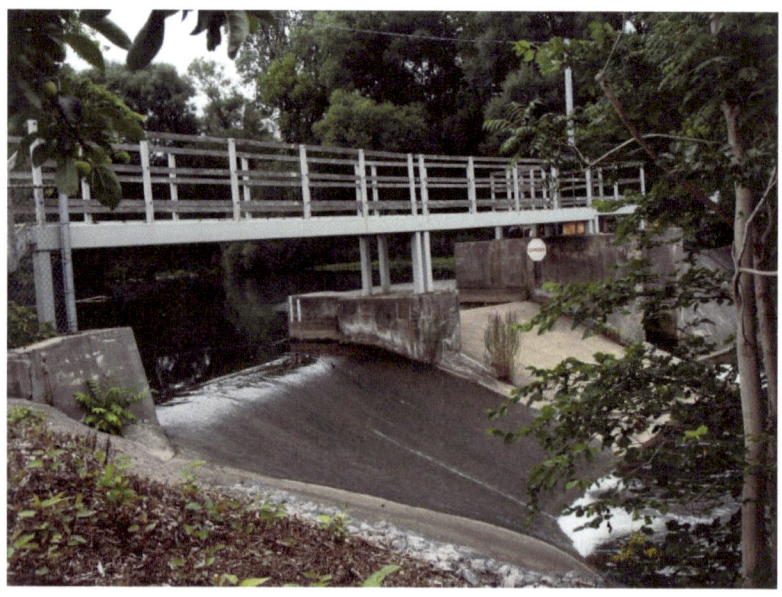

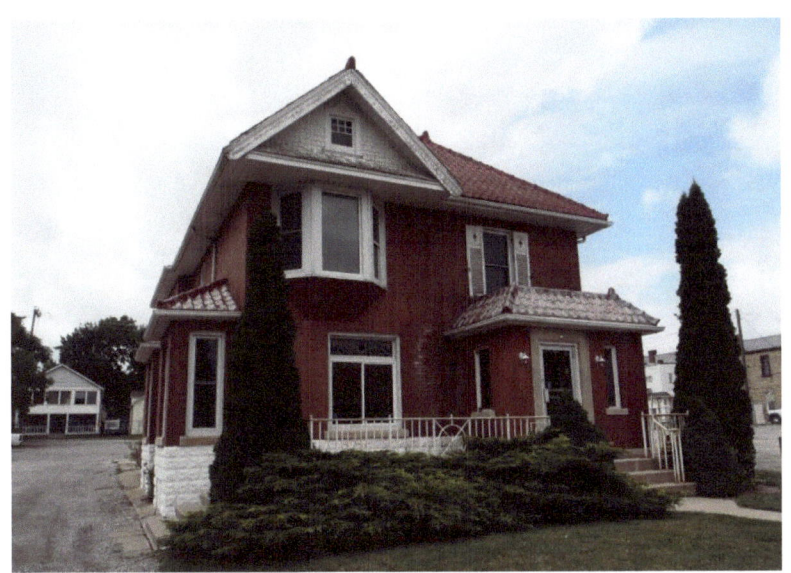

80 Norfolk Street

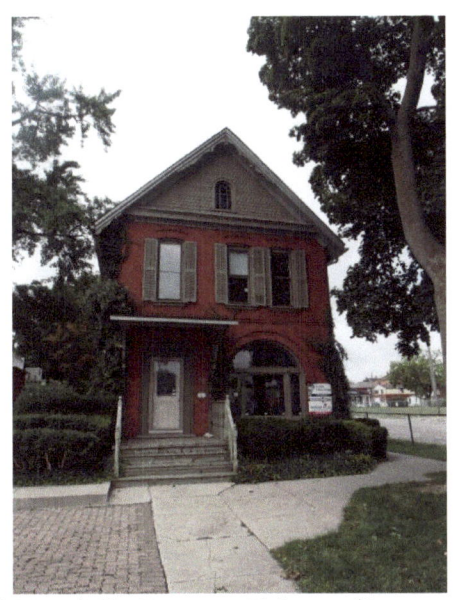

92 Norfolk Street – Edwardian style with Vergeboard trim on gable

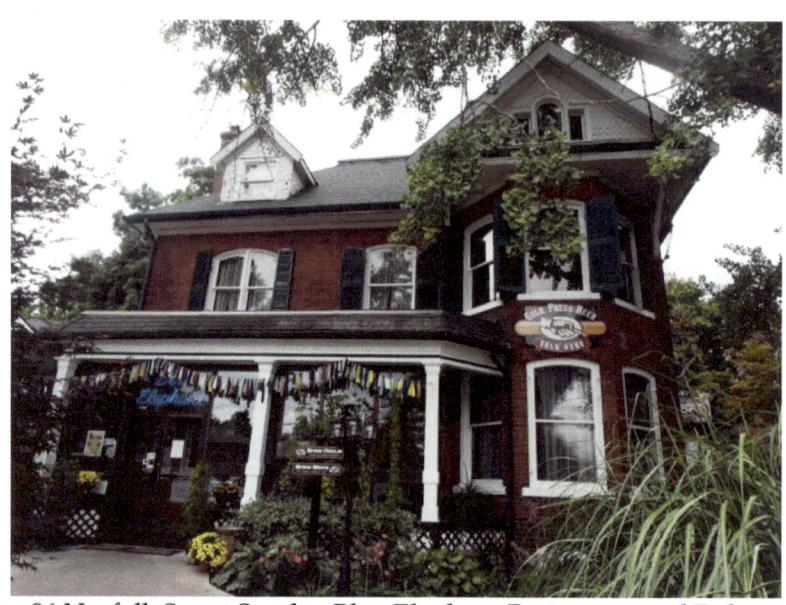

96 Norfolk Street South – Blue Elephant Restaurant and Pub - two-and-a-half storey tower-like bay with projecting eaves and large fretwork pieces resembling brackets; Palladian window in gable, dormer in hip roof

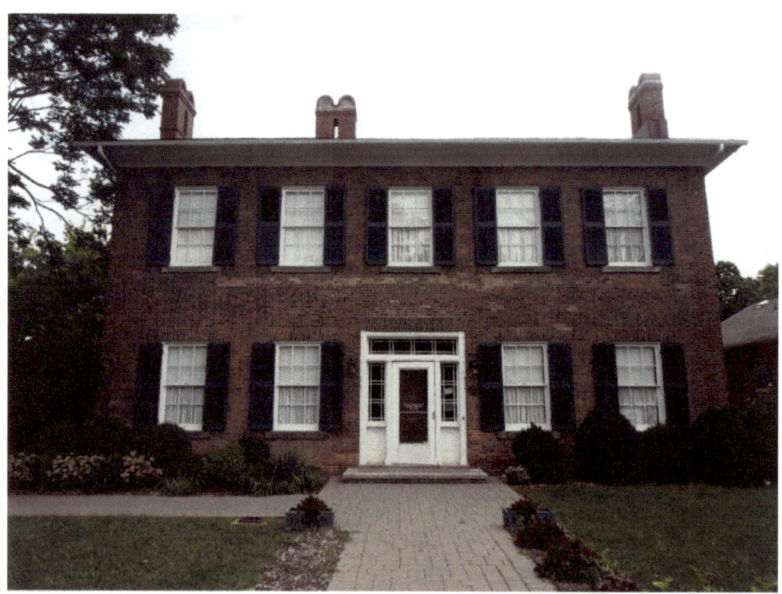

109 Norfolk Street South - Eva Brook Donly Museum – Georgian style

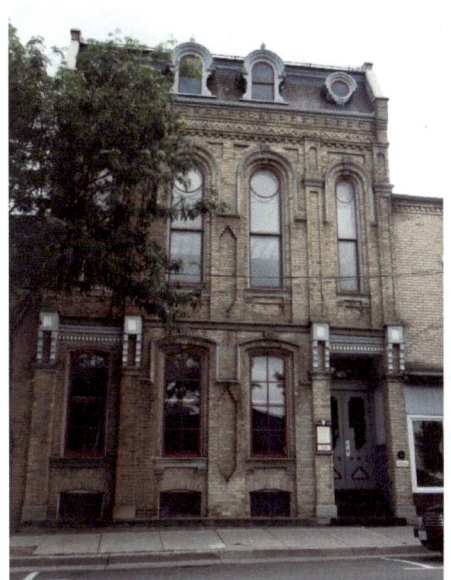 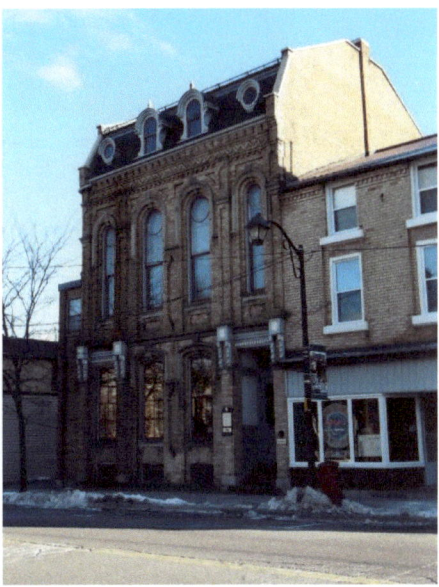

#58 – Mansard roof with dormers, voussoirs and keystones over windows, dentil moulding

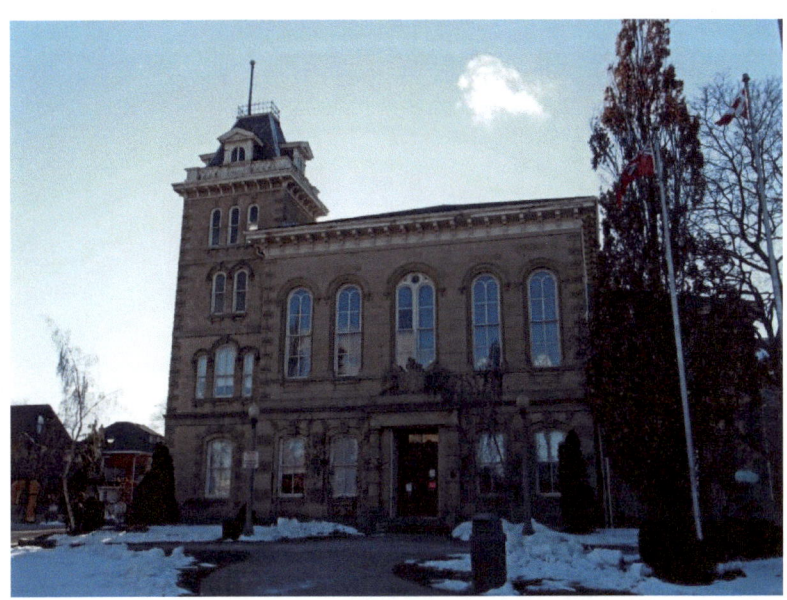

Norfolk County Court House and Gaol – built in 1864. The court house has tall round-headed windows, accentuated masonry, acroterion over doorway, corner tower with voussoirs and keystones over windows – Italianate style

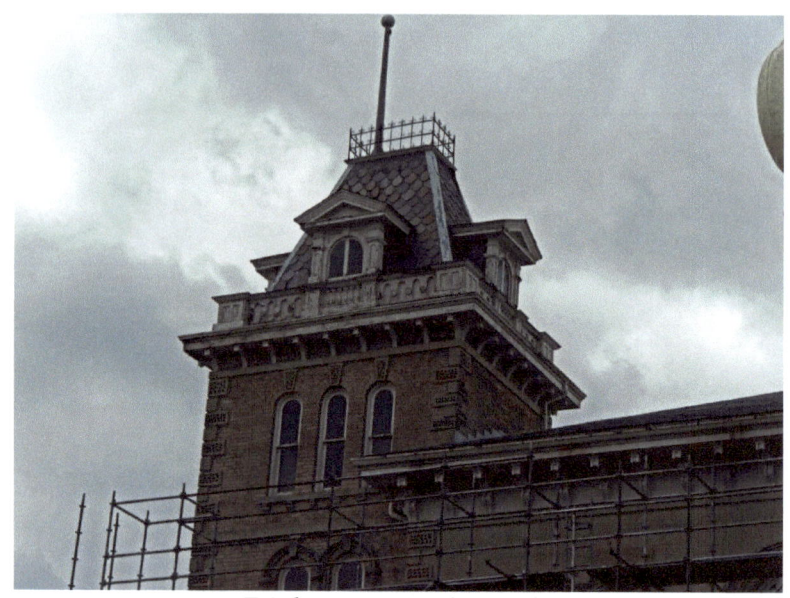
Dichromatic tilework

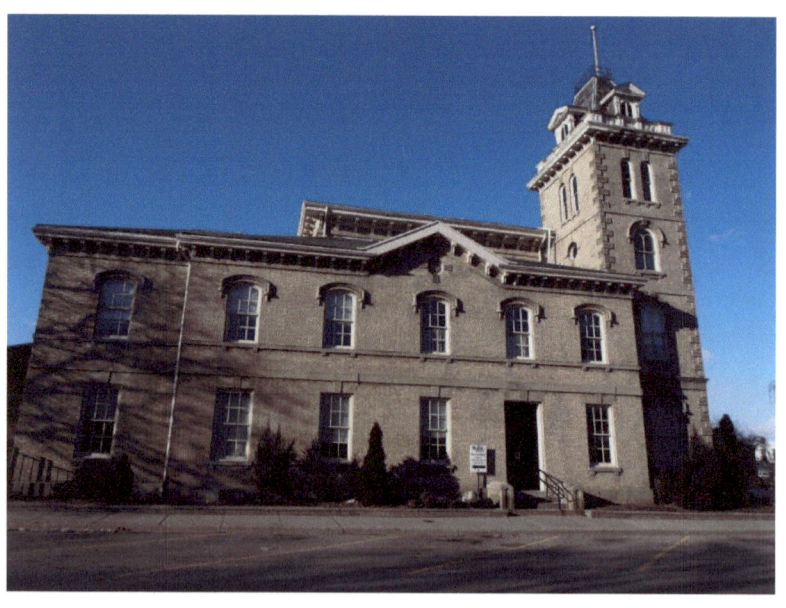

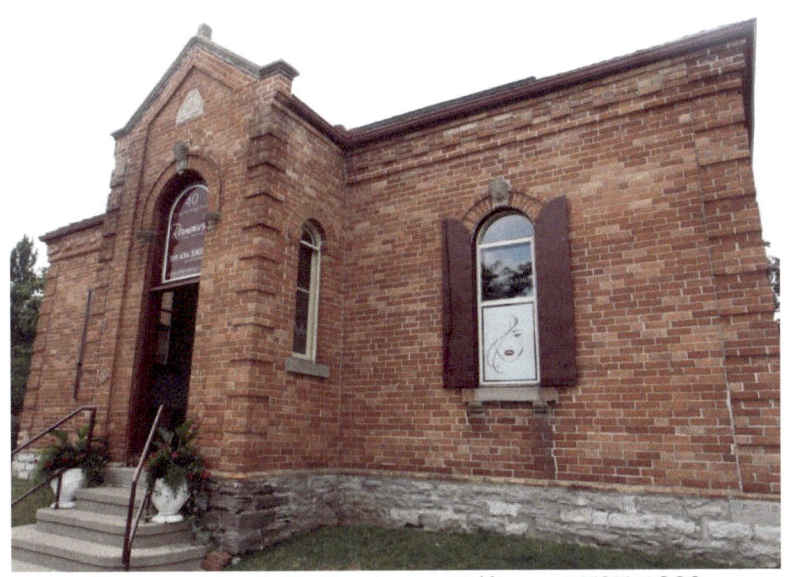

County Norfolk Registry Office – 1797-1893

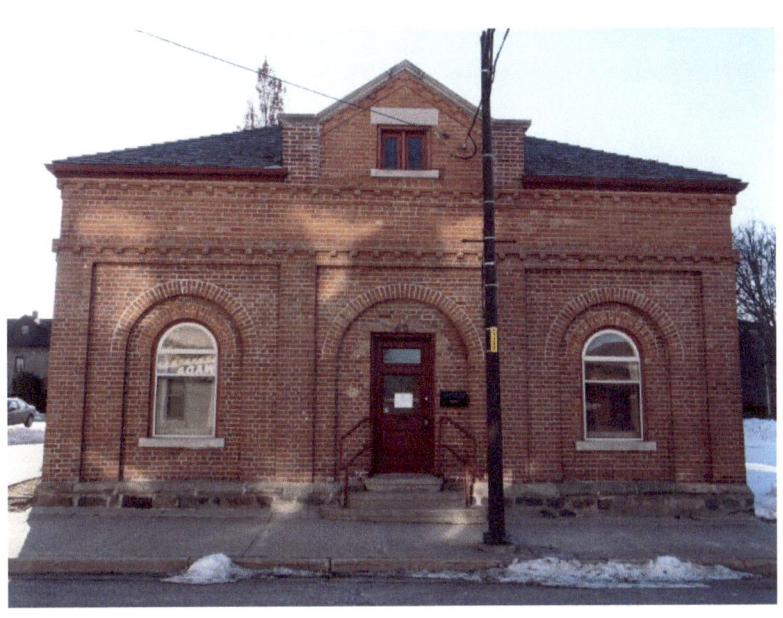

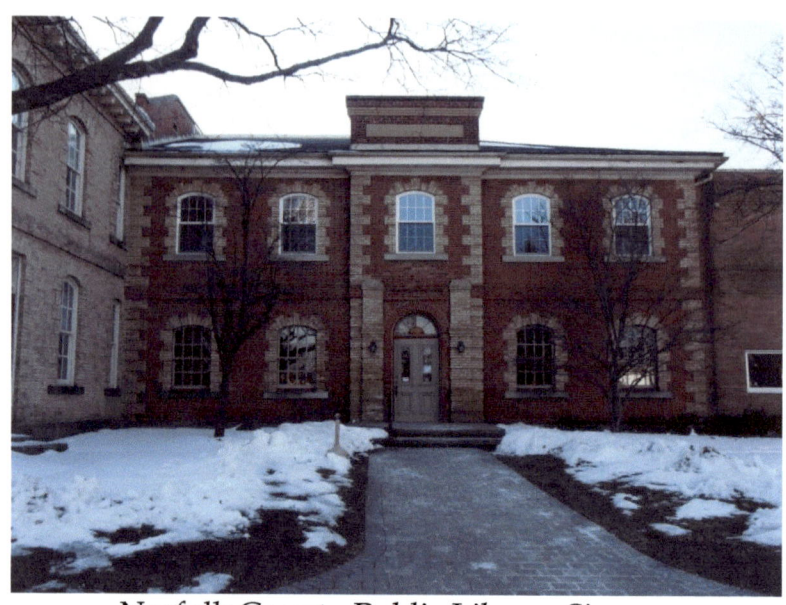
Norfolk County Public Library Simcoe – dichromatic brickwork

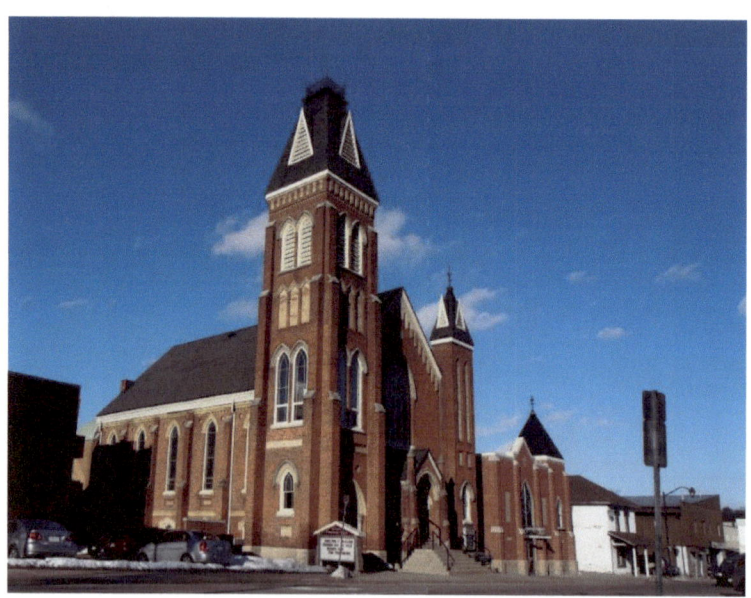
95 Lot Street - St. Paul's Presbyterian Church – Gothic Revival Lancet windows and rose window

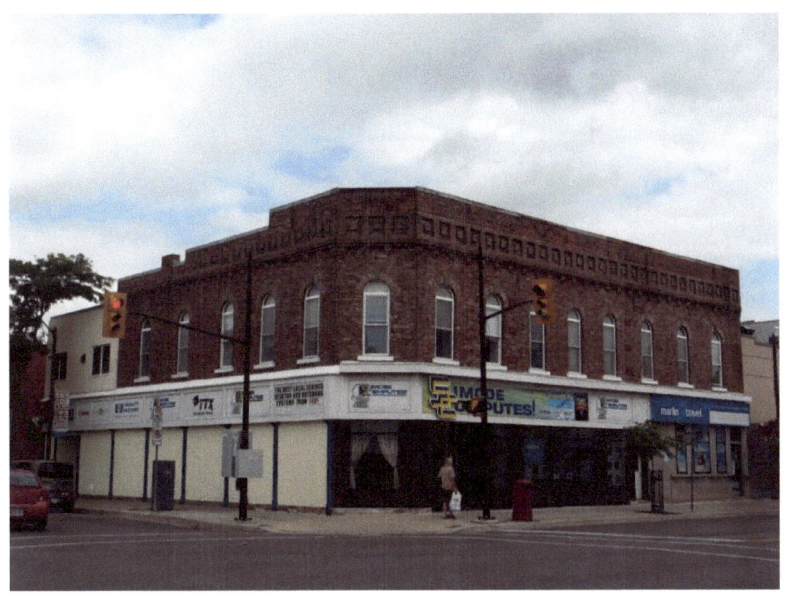

Decorative brickwork

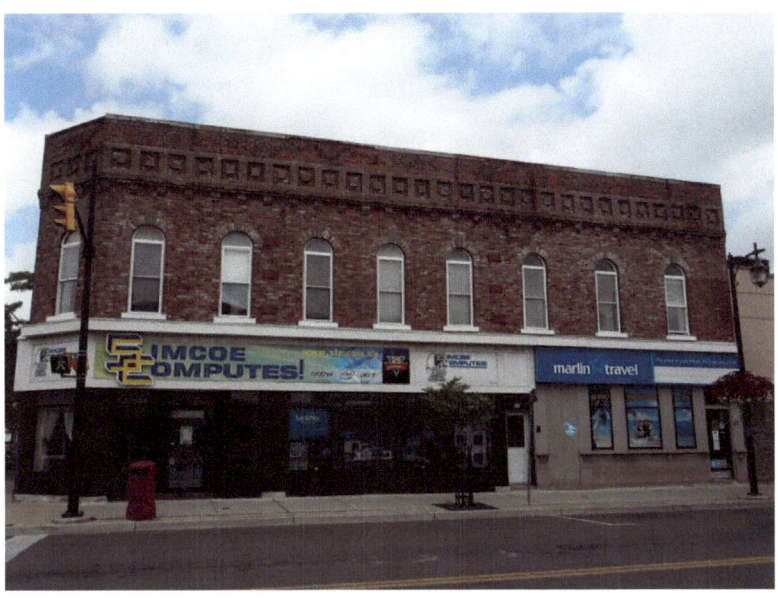

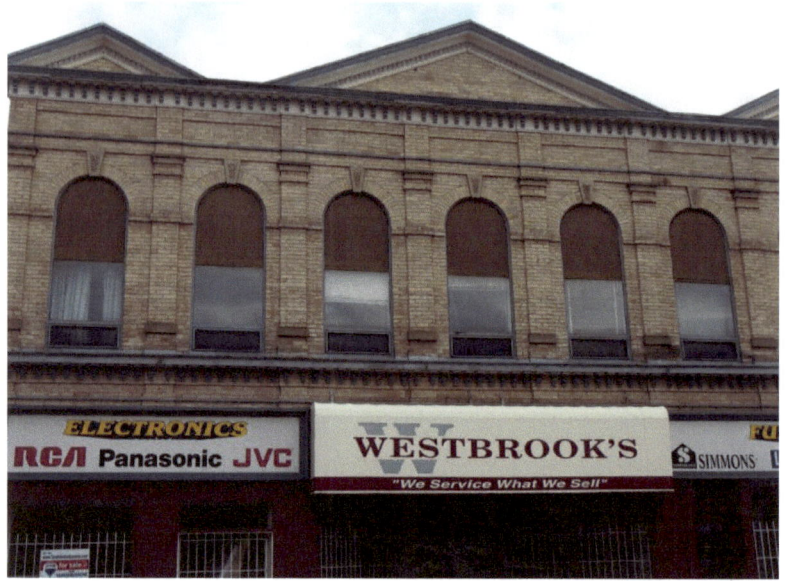

Cornice brackets, arched window voussoirs and keystones

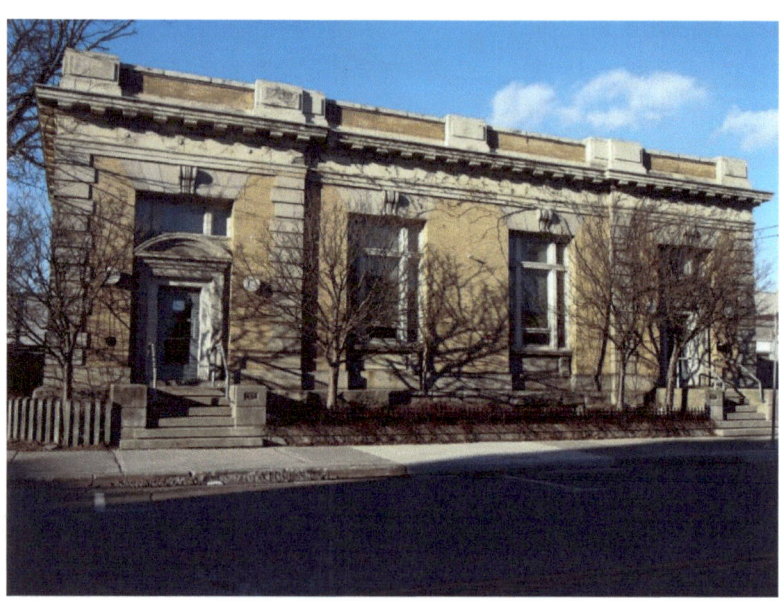

#45A - keystones

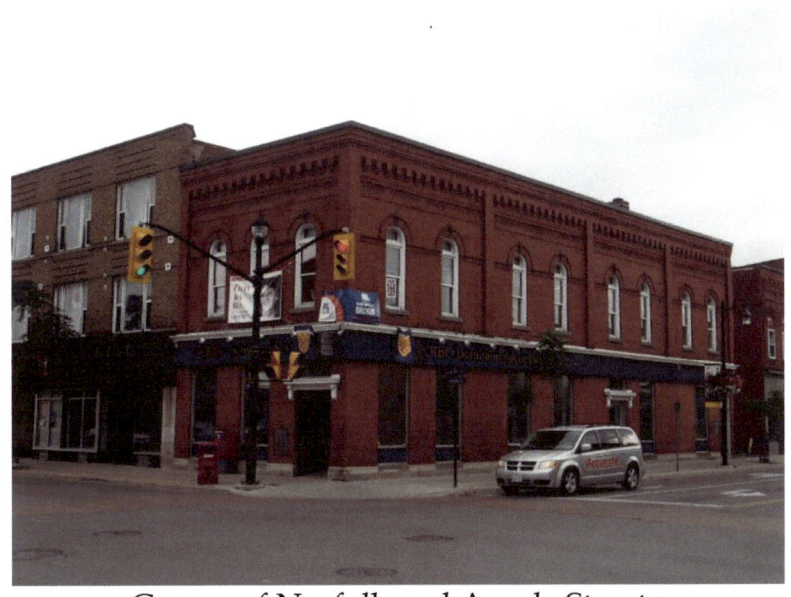

Corner of Norfolk and Argyle Streets

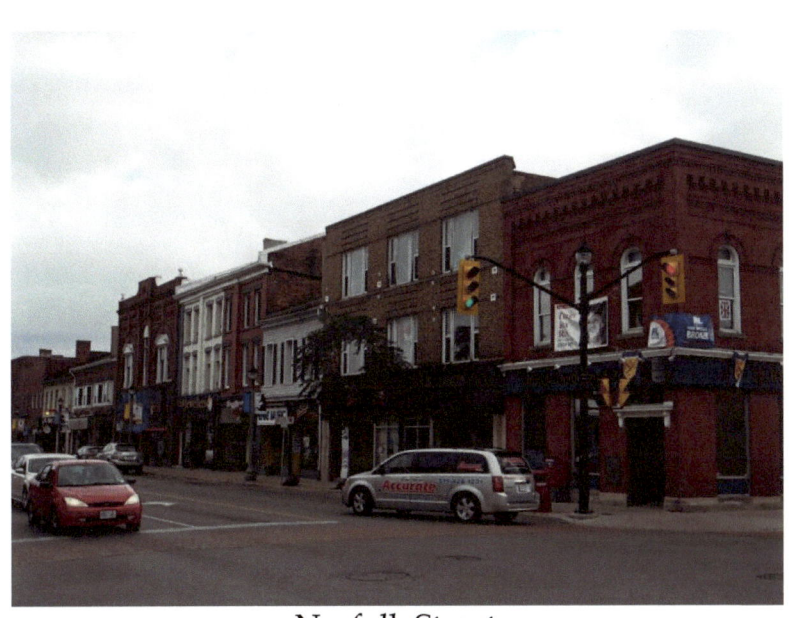

Norfolk Street

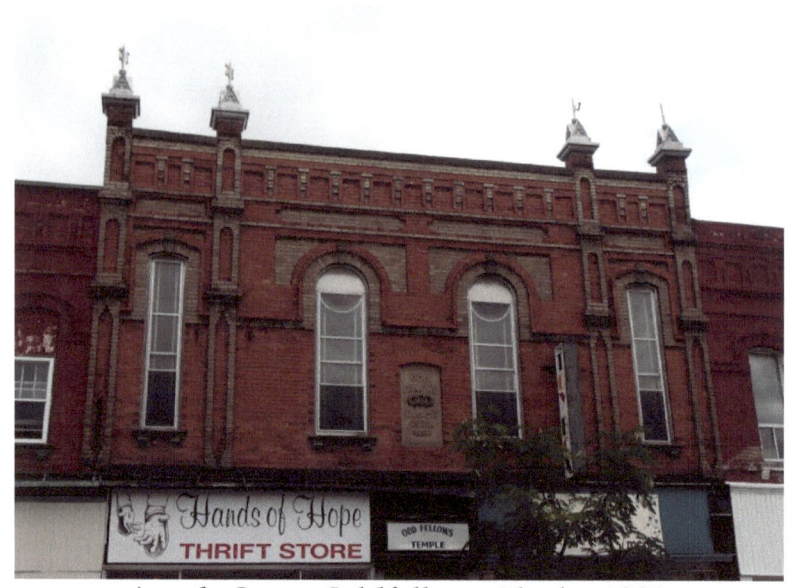

Argyle Street Oddfellows Block - 1888

Dormers in second floor

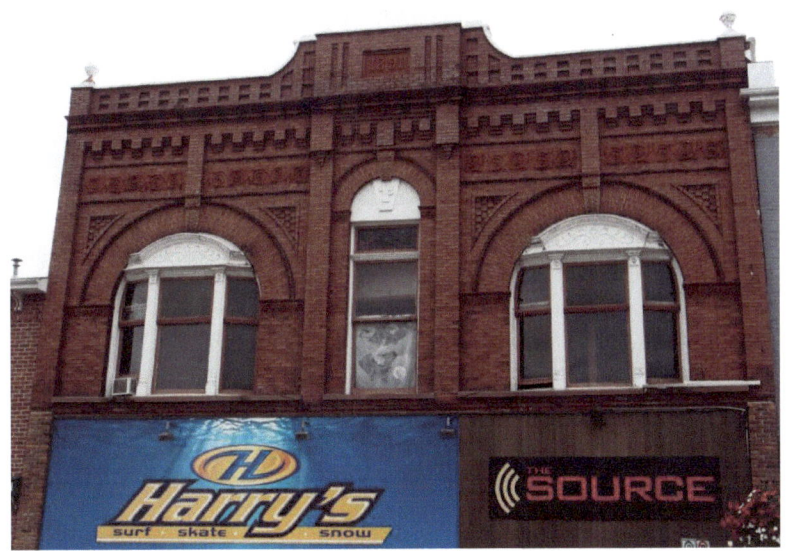

1891

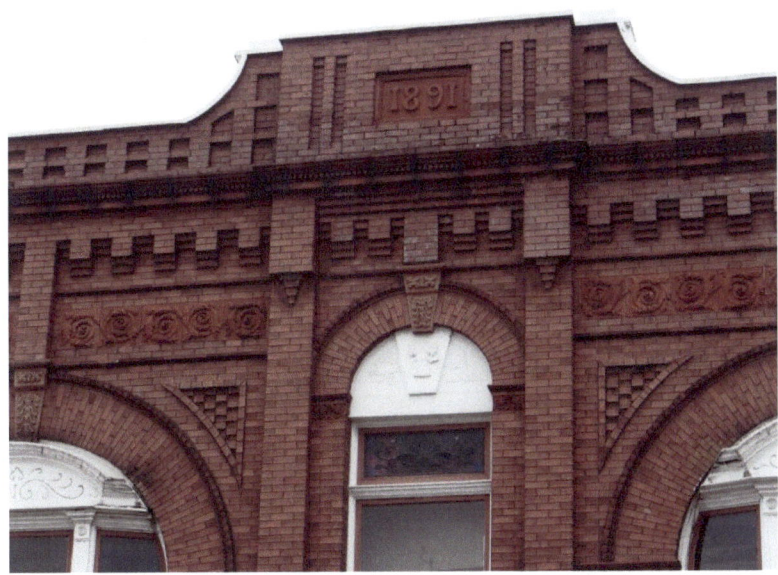

Dentil moulding and other decorative brickwork

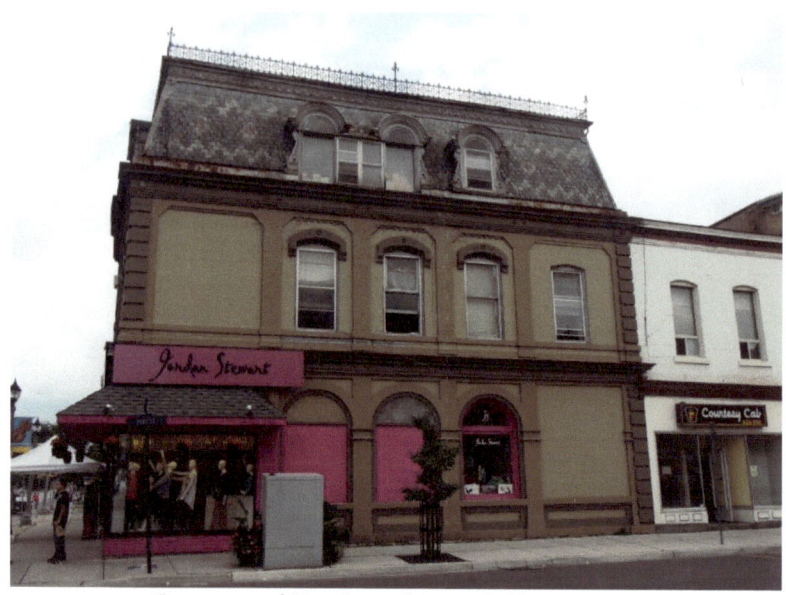
Corner of Peel and Norfolk Streets

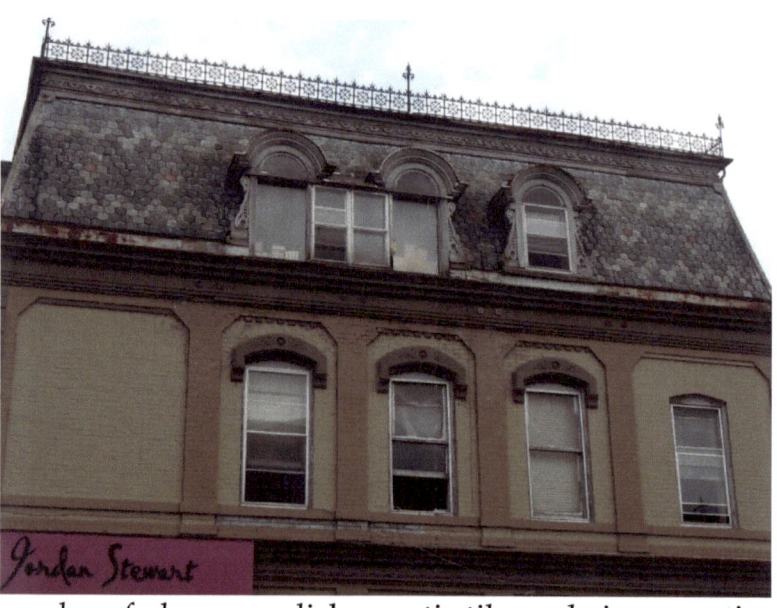
Mansard roof, dormers, dichromatic tilework, iron cresting on rooftop, decorative window hoods

Old brick building – dormers on second floor

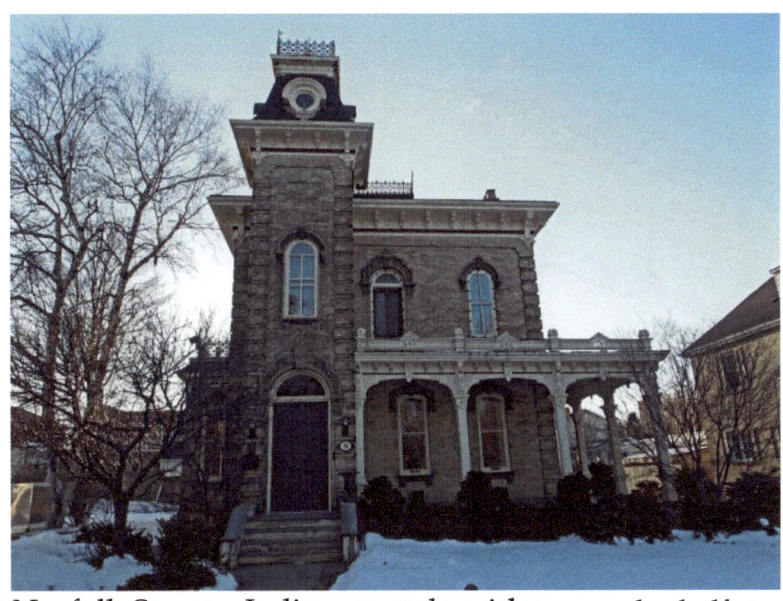

94 Norfolk Street – Italianate style with two-and-a-half storey tower-like bay topped with a cupola with iron cresting on top; decorative voussoirs and keystones

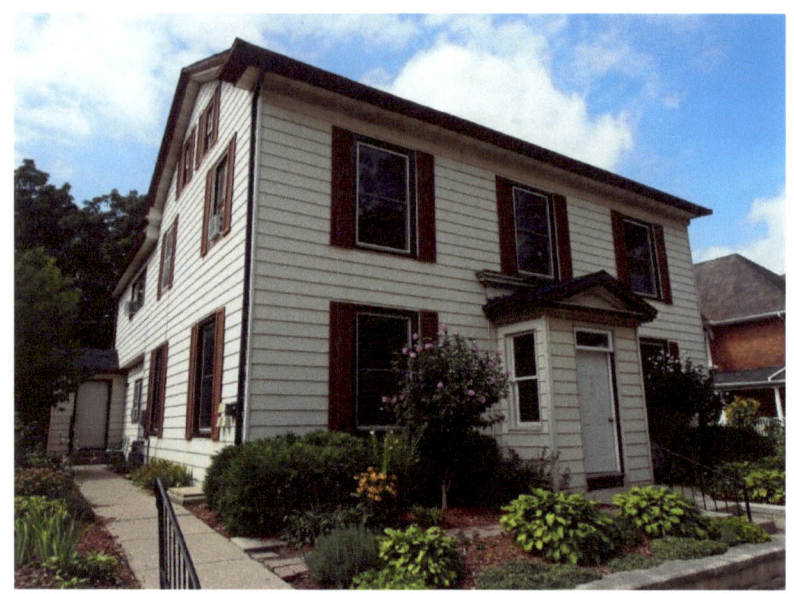

Norfolk Street

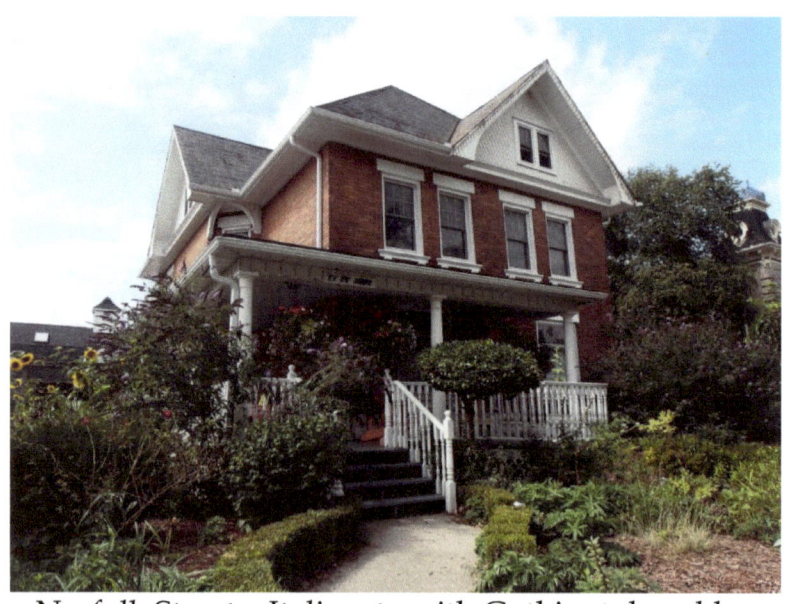

Norfolk Street – Italianate with Gothic style gables

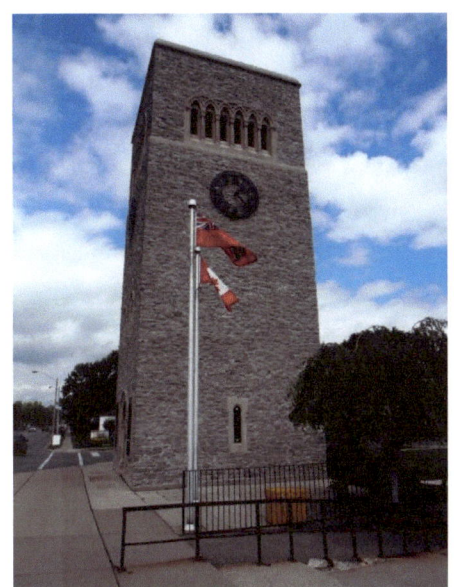 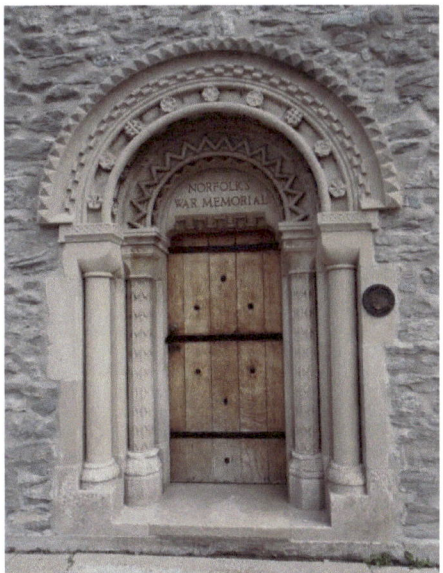

The Norfolk County Memorial Tower with carillon tower commemorates the lives of Canadians who died for Canada in conflicts overseas. The Memorial Tower overlooks Wellington Park with walking paths and a waterway system with a small lake.

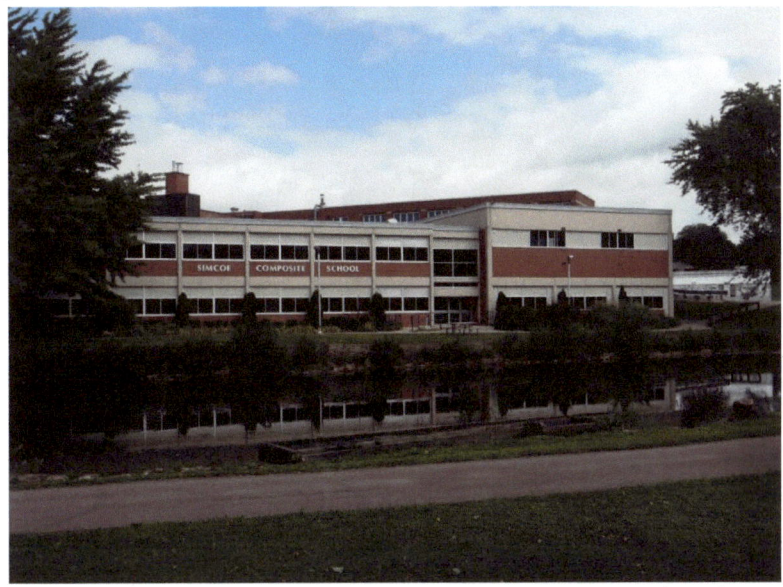

40 Wilson Avenue – Simcoe Composite School

Reflections

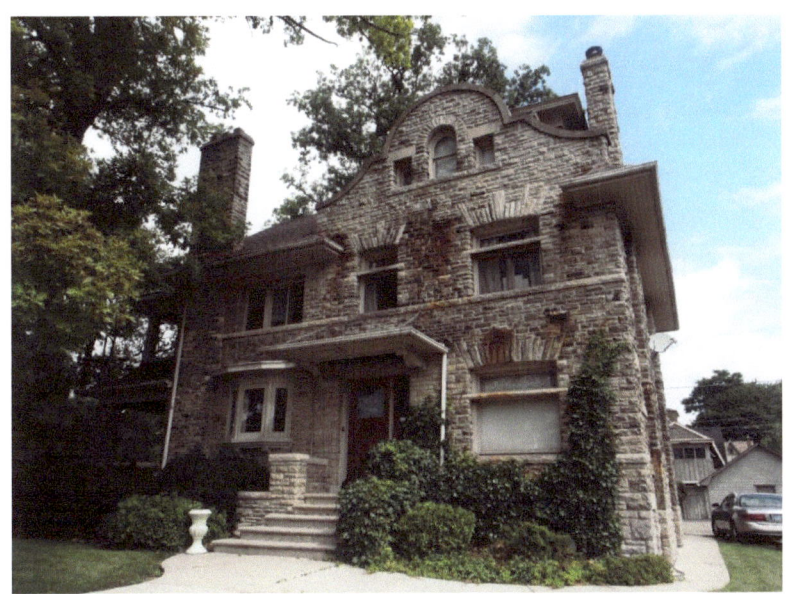

Norfolk Street at corner of Lynn Park Drive
Stone mansion, Palladian window in round gable, decorative voussoirs, deep verandahs, enclosed verandah on second floor at rear

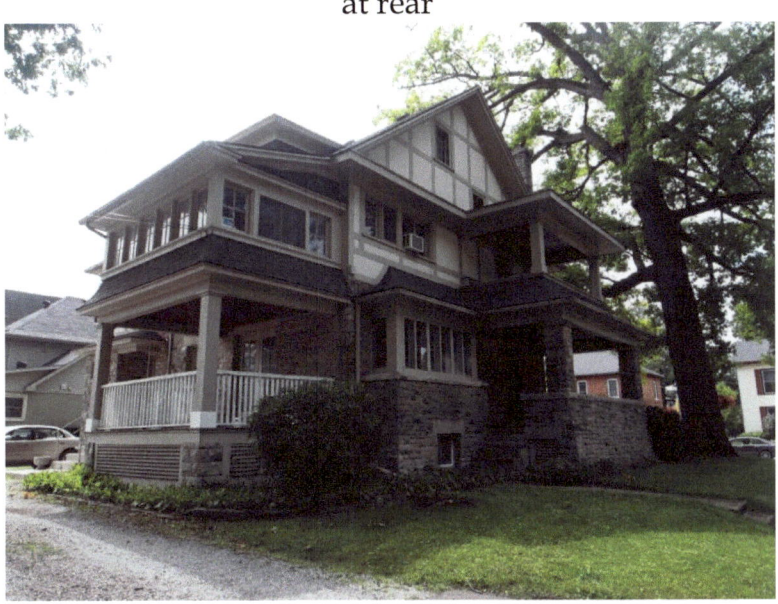

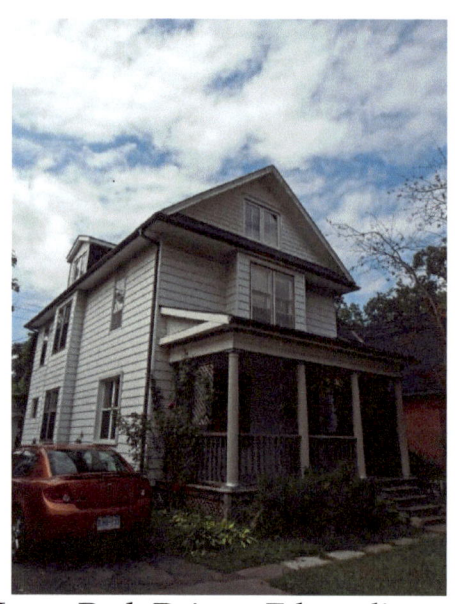
66 Lynn Park Drive – Edwardian style

Dormers in attic

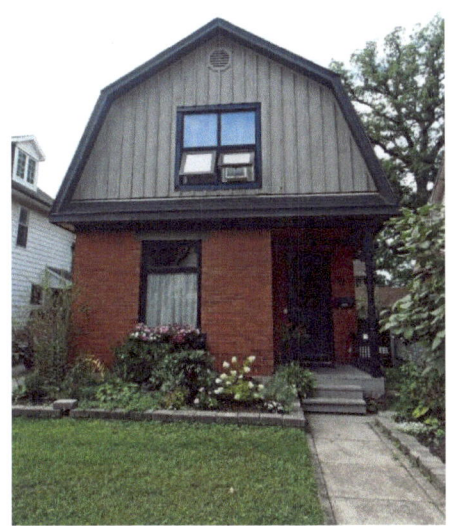

72 Lynwood Drive

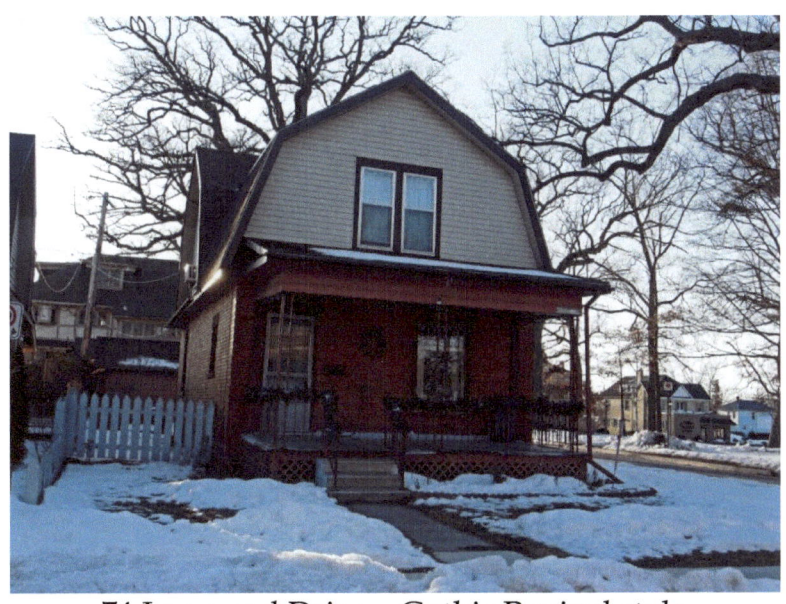

74 Lynwood Drive – Gothic Revival style

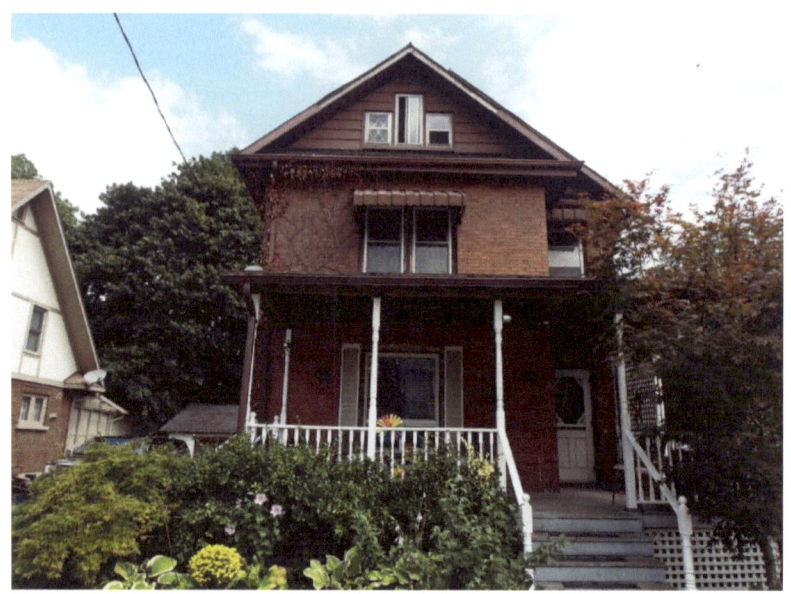
62 Lynwood Drive – Edwardian style with Palladian window

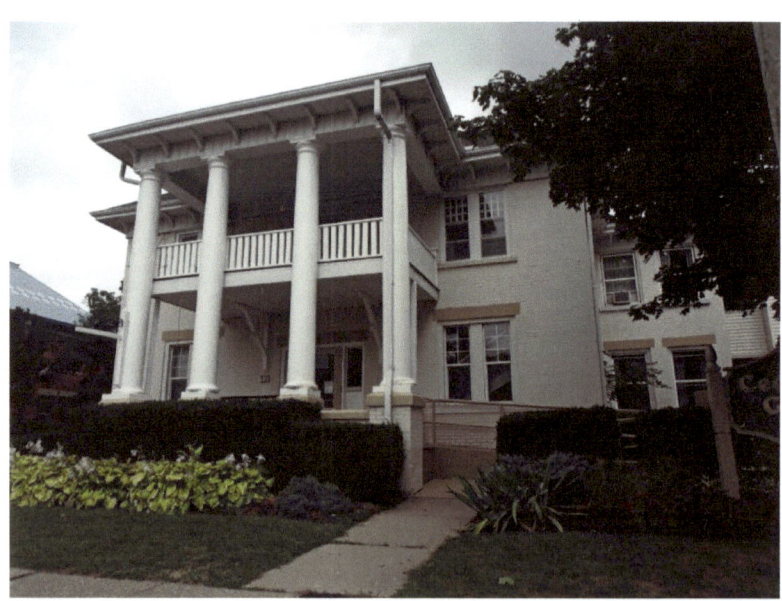
121 Colborne Street – Italianate style with two-storey pillars supporting the roof of verandahs on both levels

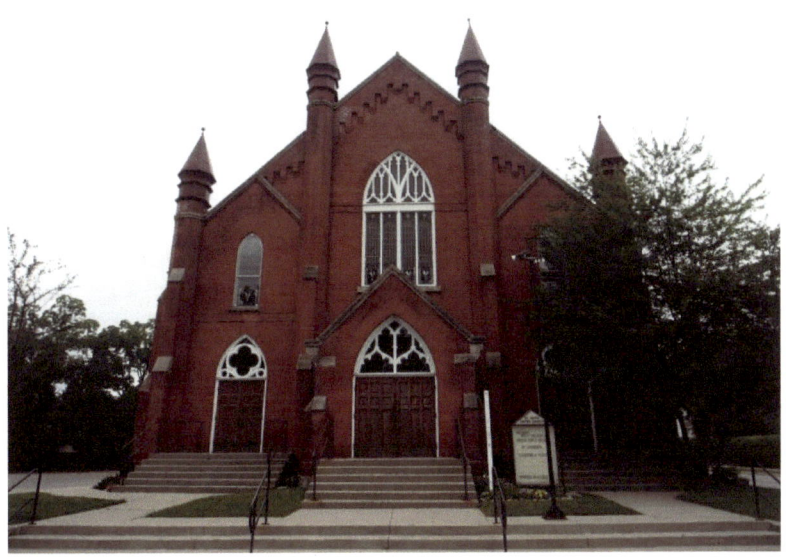

150 Colborne Street – St. James United – Gothic style - tower-like buttresses with cone-shaped caps, decorative brickwork

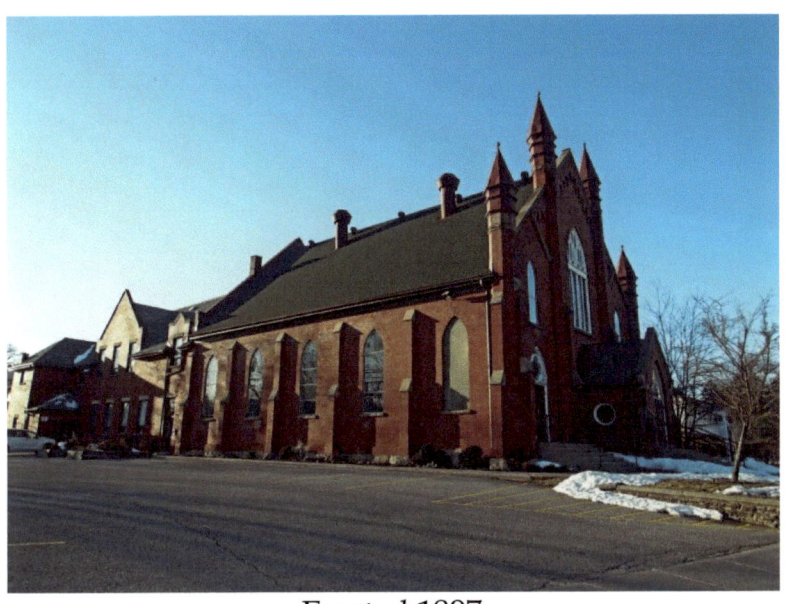

Erected 1897

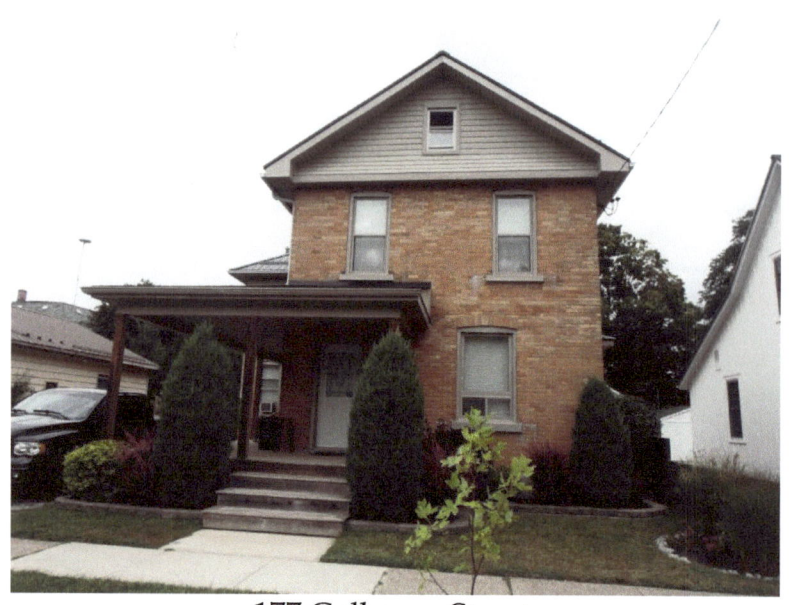

177 Colborne Street

182 Colborne Street – Italianate style, cornice brackets

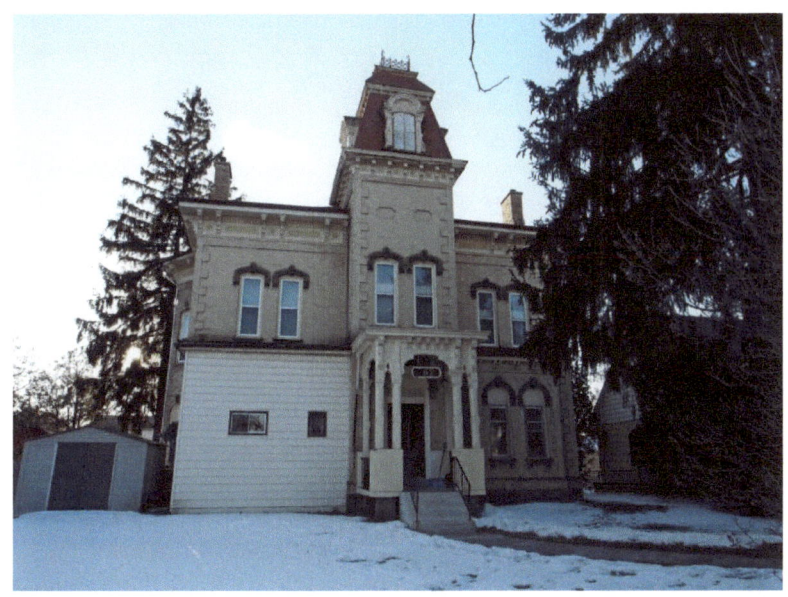

162 Colborne Street – Italianate style with three storey tower-like bay topped with a cupola with iron cresting on top; decorative window voussoirs and keystones

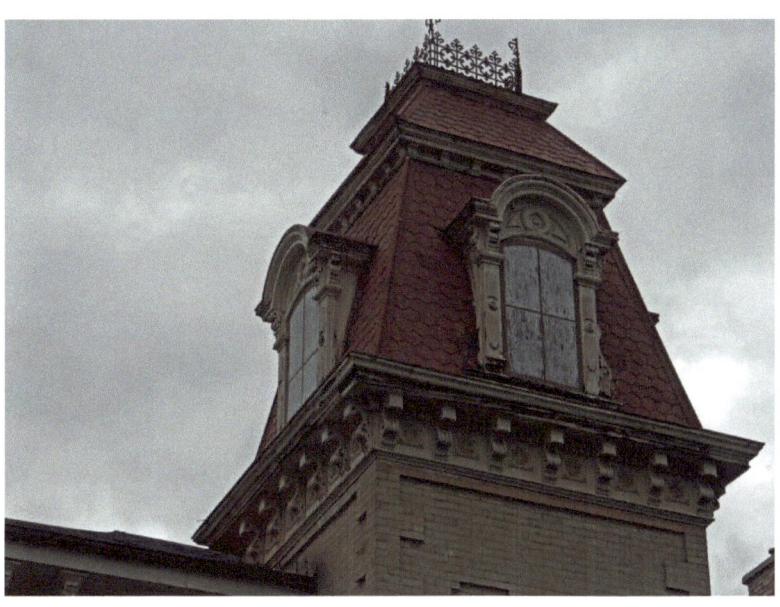

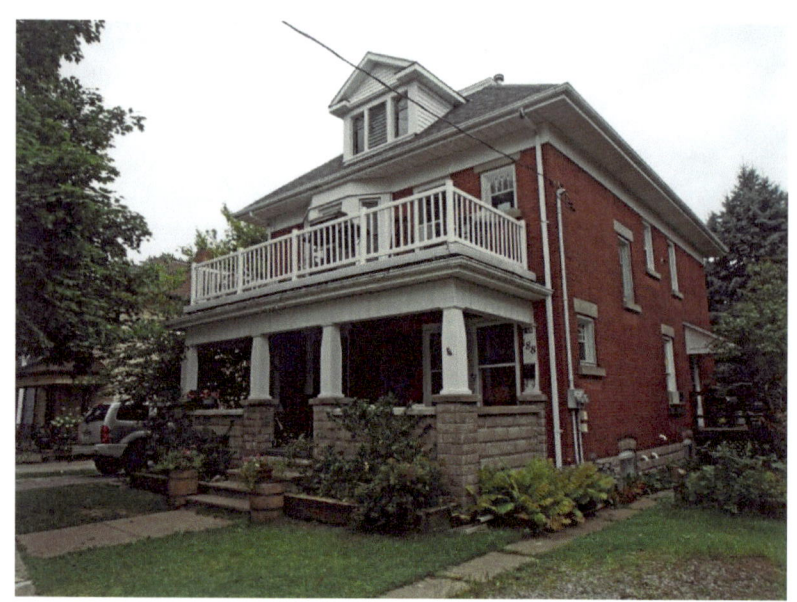

188 Colborne Street

358 Colborne Street – Italianate with dormer in attic

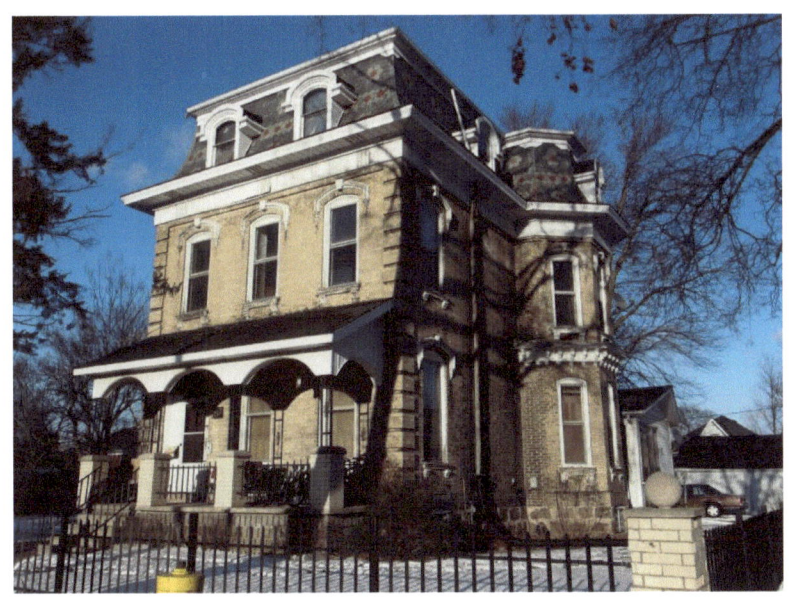

217 Colborne Street – Second Empire style – mansard roof, dichromatic tilework

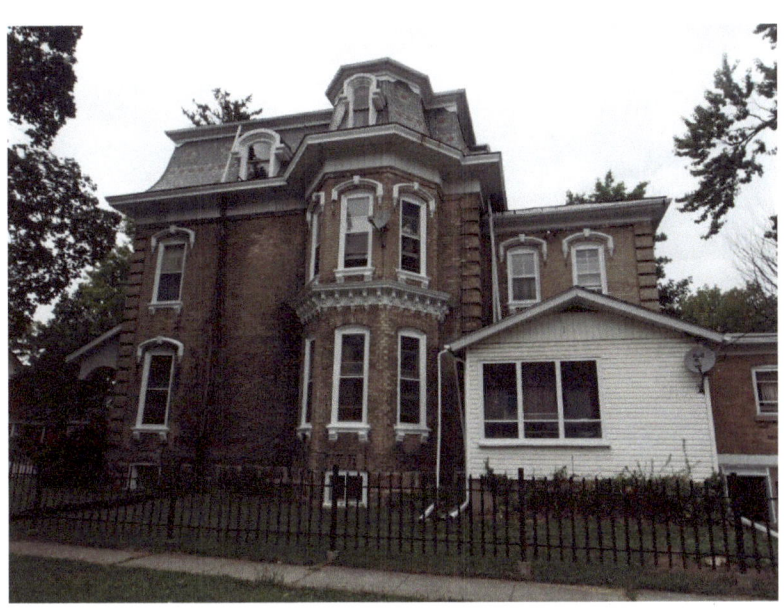

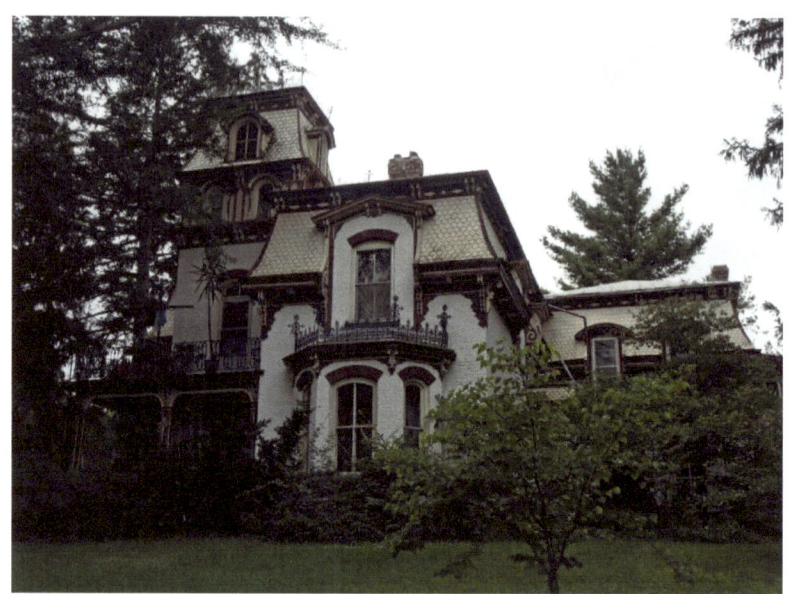

364 Colborne Street – old castle – Queen Anne style with four-storey tower with iron cresting on top; iron cresting above ground floor bay window, elaborate cornice brackets

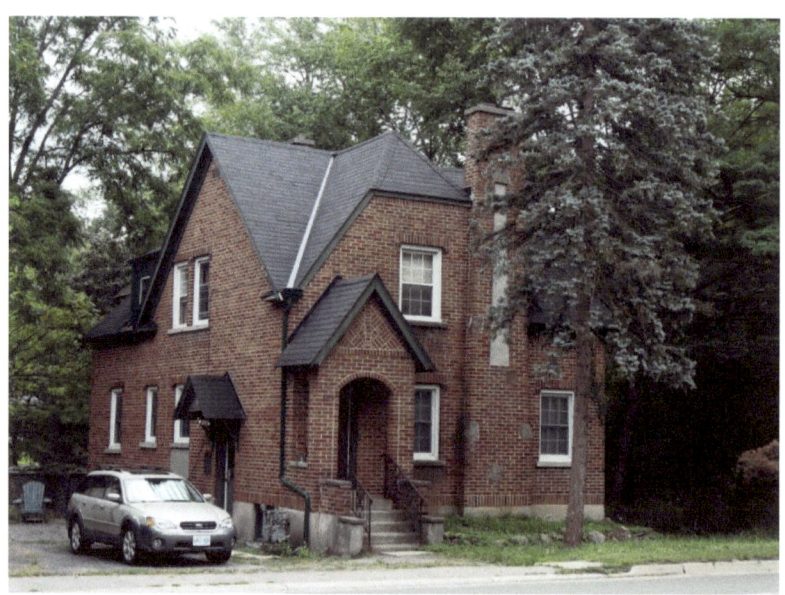

Colborne Street

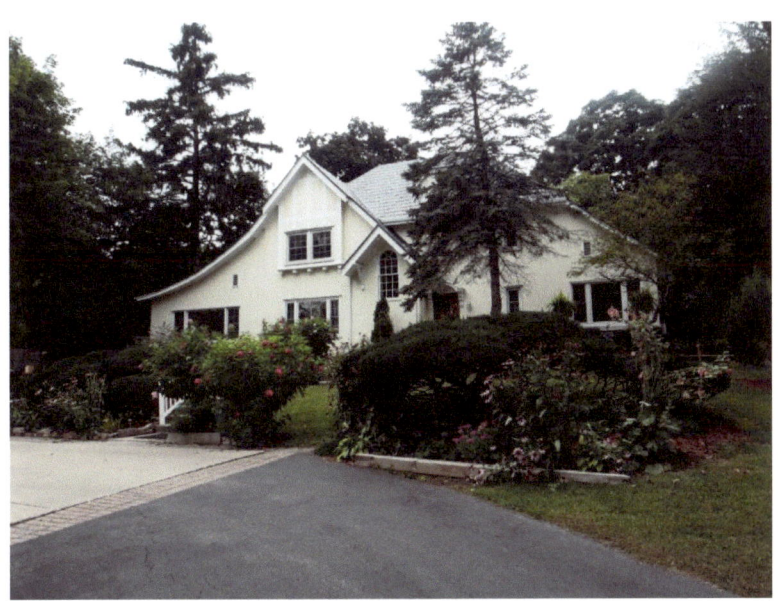

Colborne Street

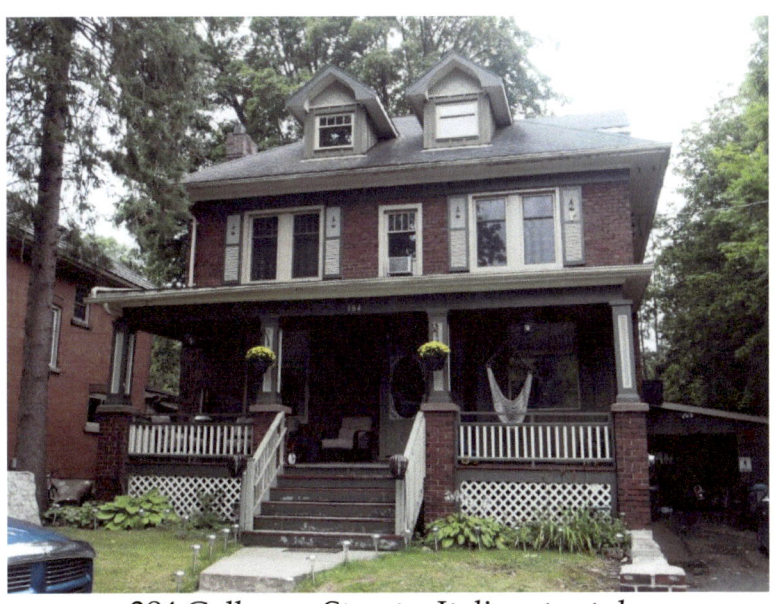

384 Colborne Street – Italianate style
with dormers in hipped roof

390 Colborne Street – Italianate style with two-and-a-half storey tower-like bay

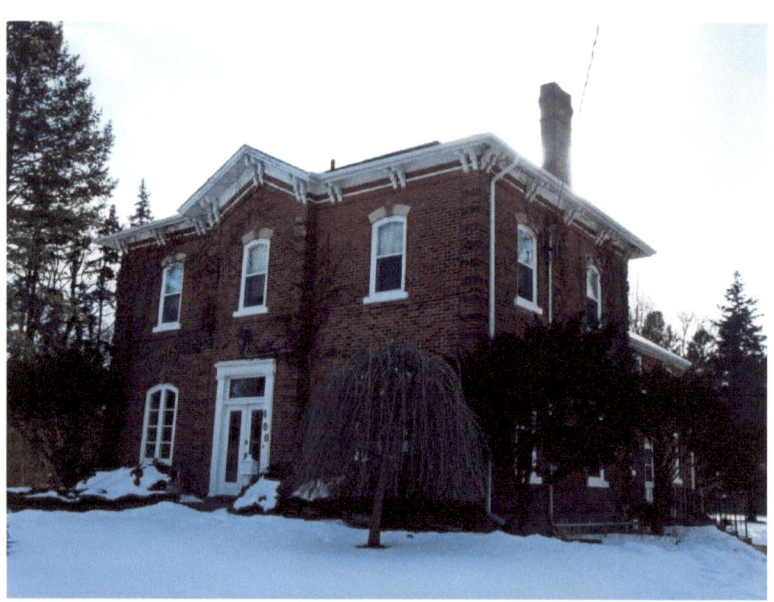

400 Colborne Street – Italianate style, cornice brackets, 2-storey frontispiece, corner quoins, window voussoirs and keystones

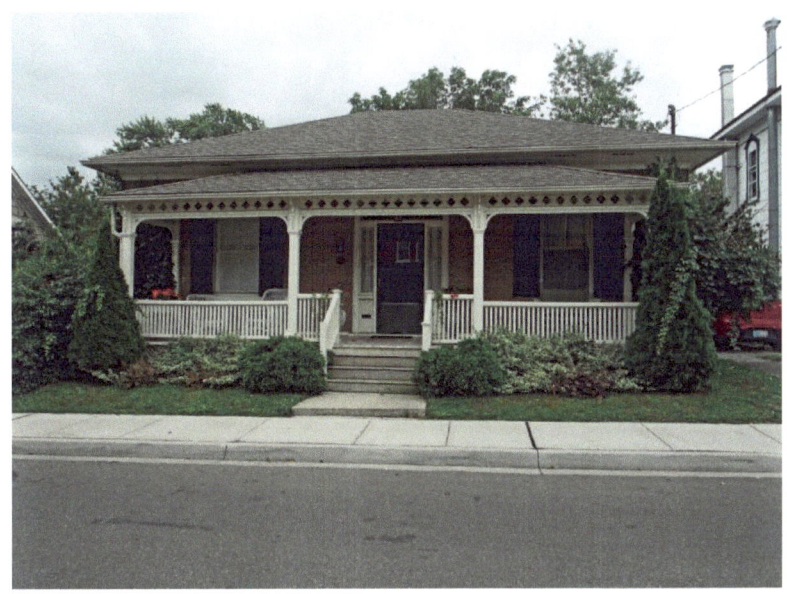

Colborne Street – Regency Cottage – one storey

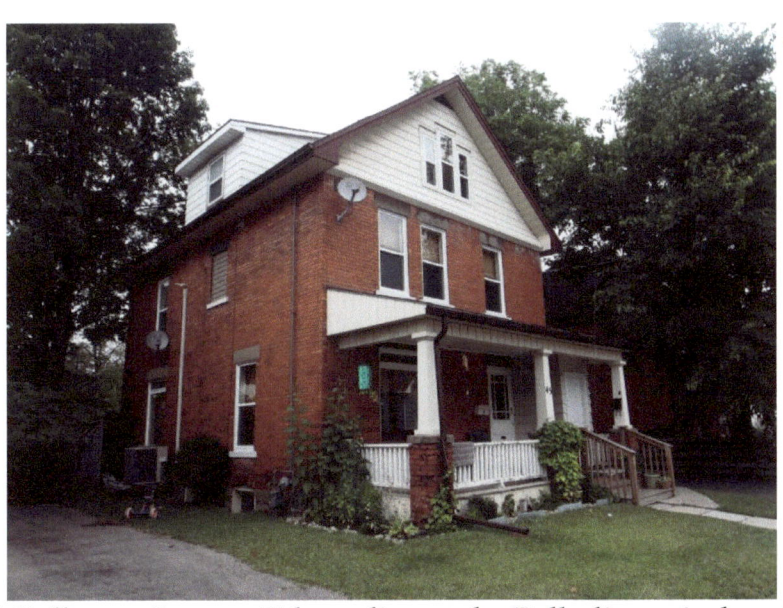

45 Colborne Street – Edwardian style, Palladian window in gable, dormer in attic

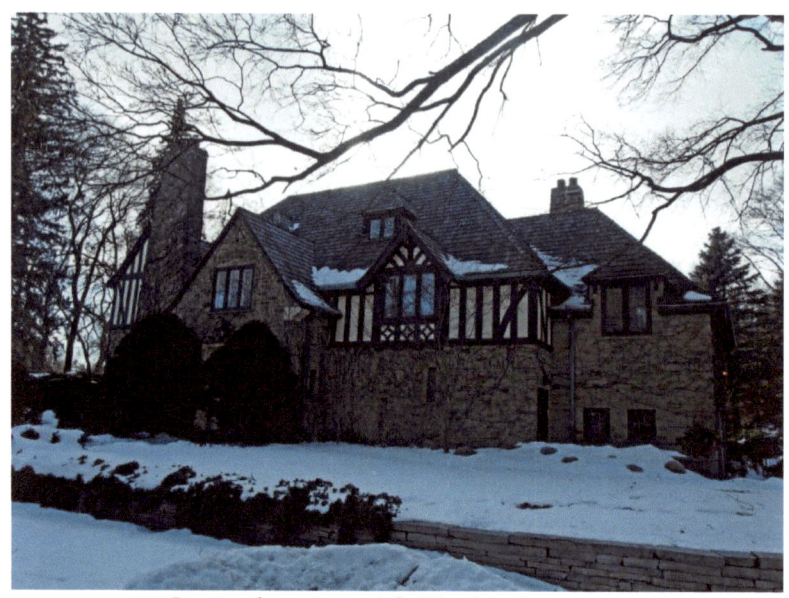
Stone house with Tudor accents

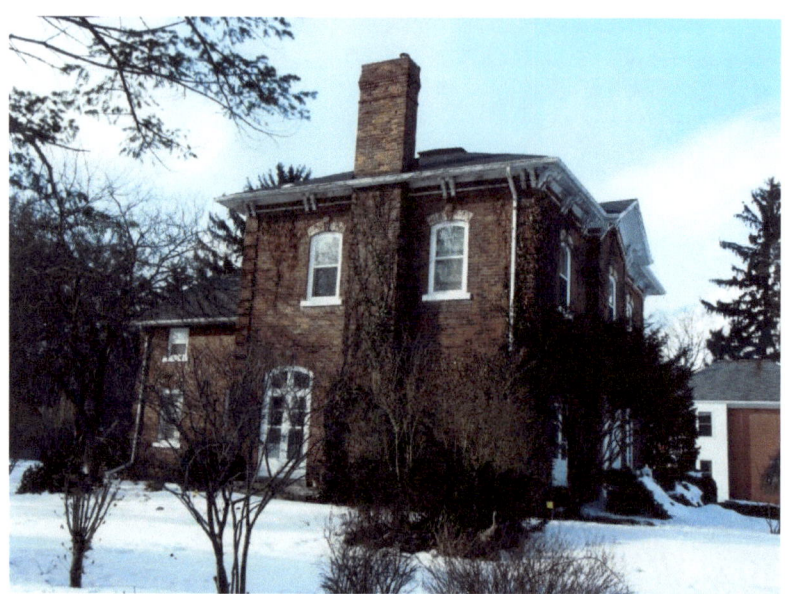
Italianate with two-storey frontispiece

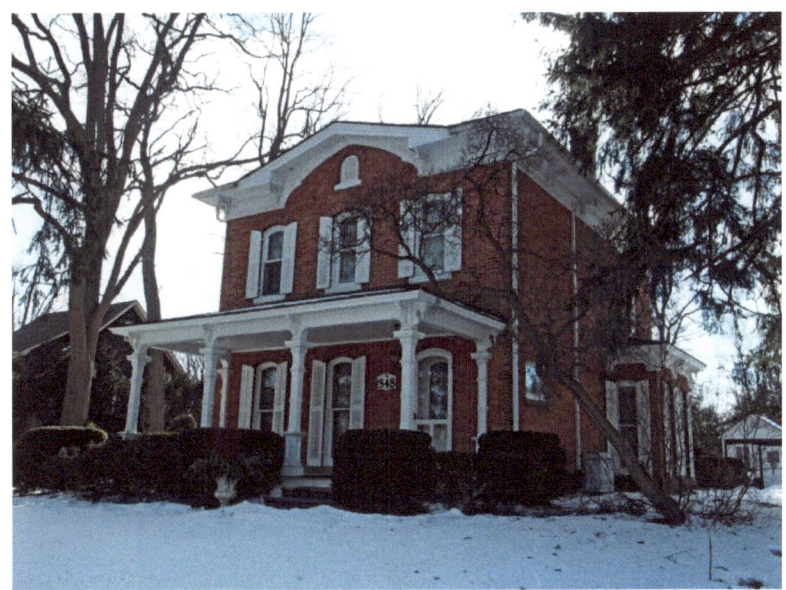

#348 – Italianate style – cornice brackets

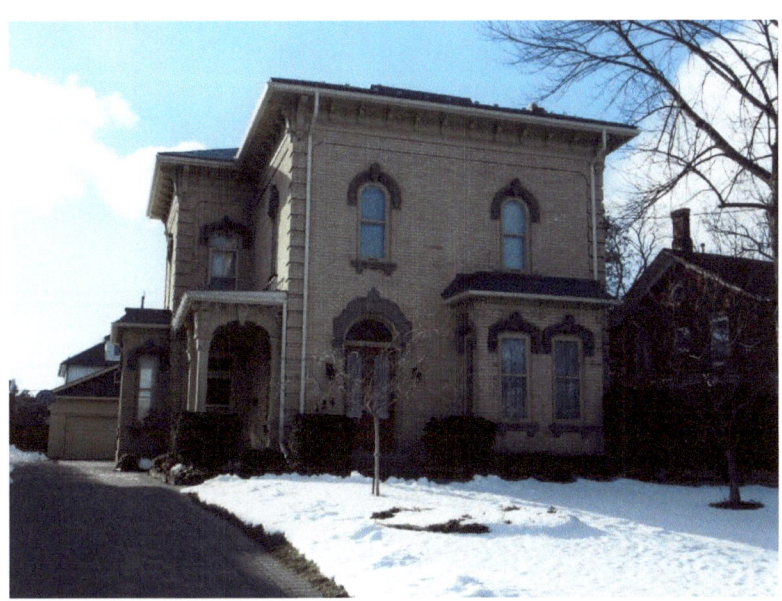

Italianate with decorative window voussoirs and keystones

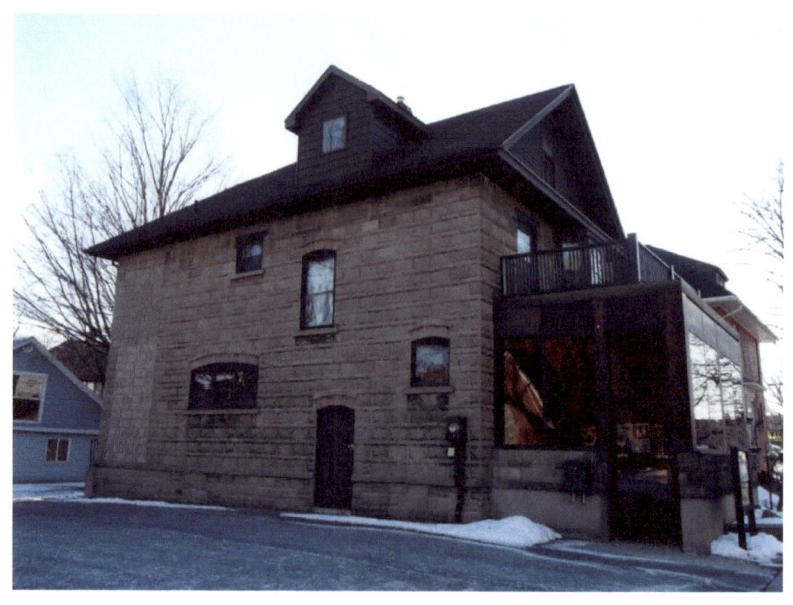

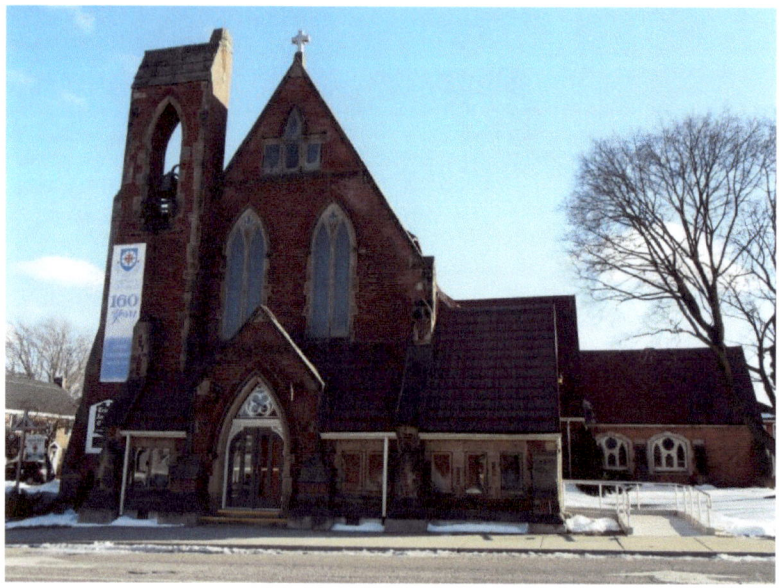

80 Colborne Street South, Trinity Anglican Church

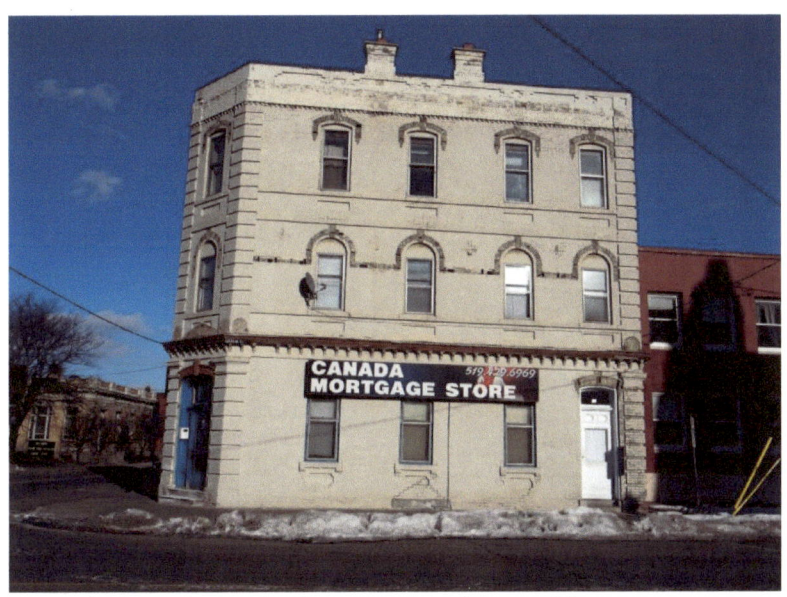

decorative window voussoirs and keystones

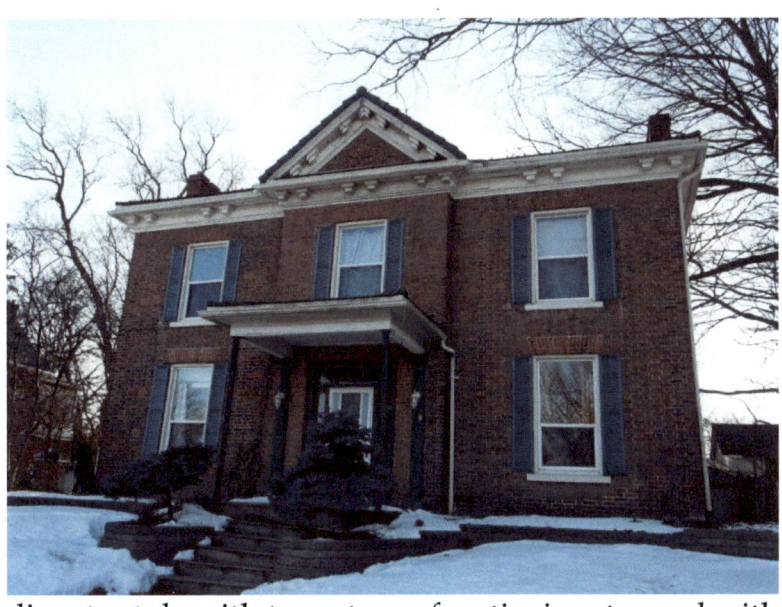

Italianate style with two-storey frontispiece topped with a gable in the roof

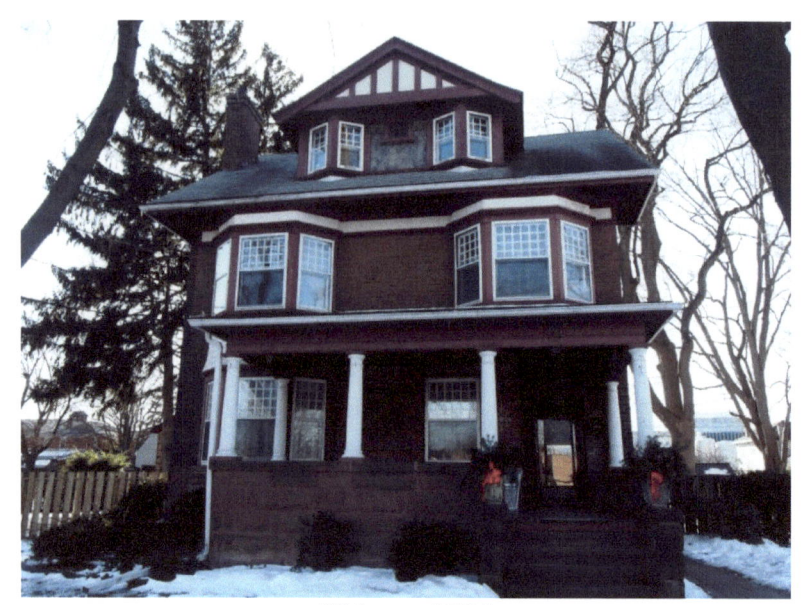

#96 – c. 1906

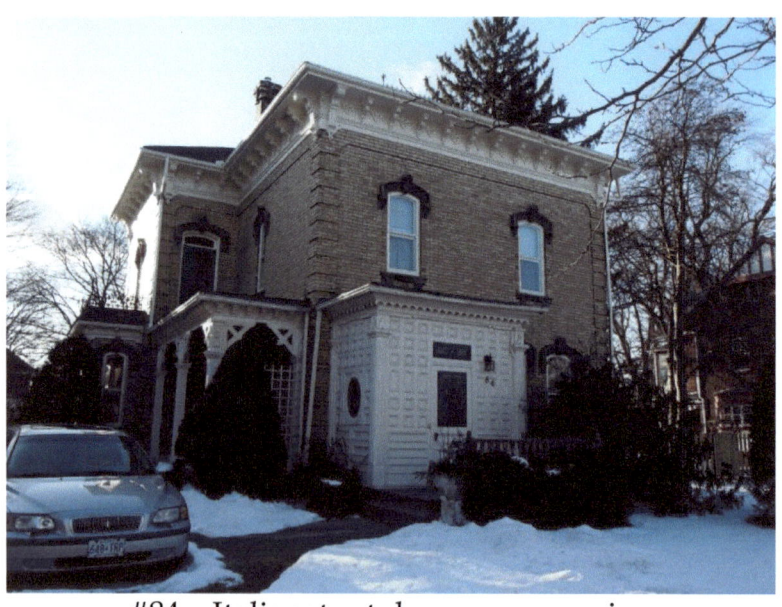

#84 – Italianate style – corner quoins

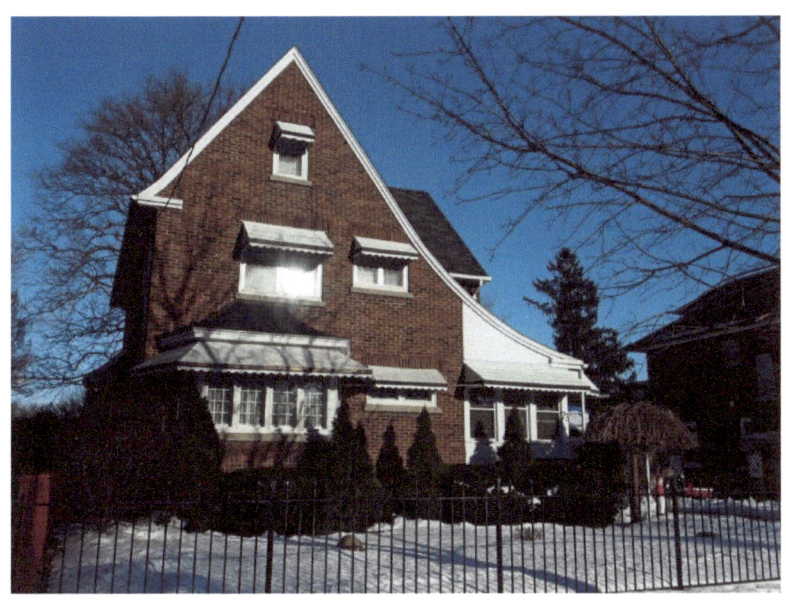

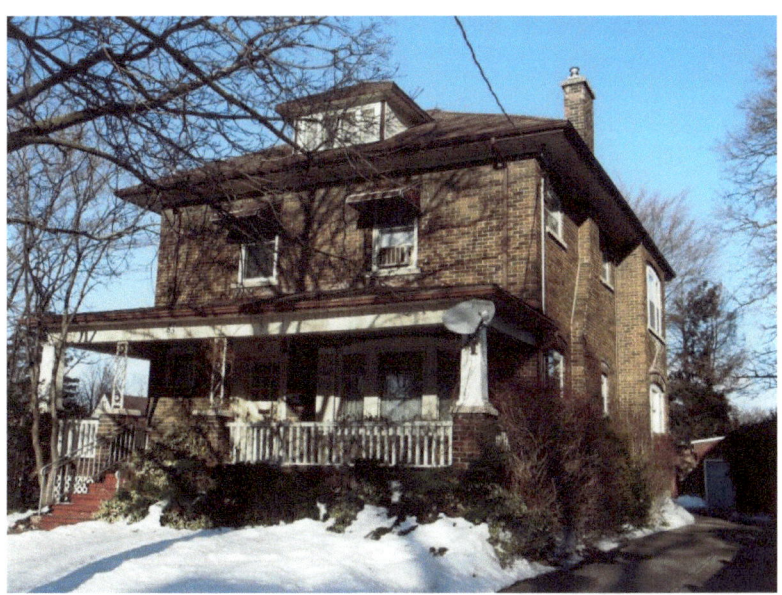

#83 – Italianate, dormer in attic

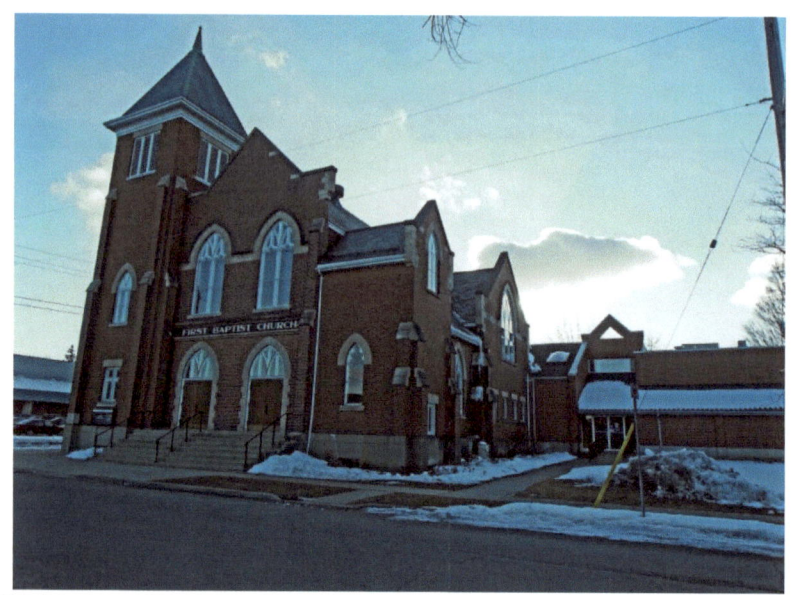

129 Young Street – First Baptist Church – established 1836

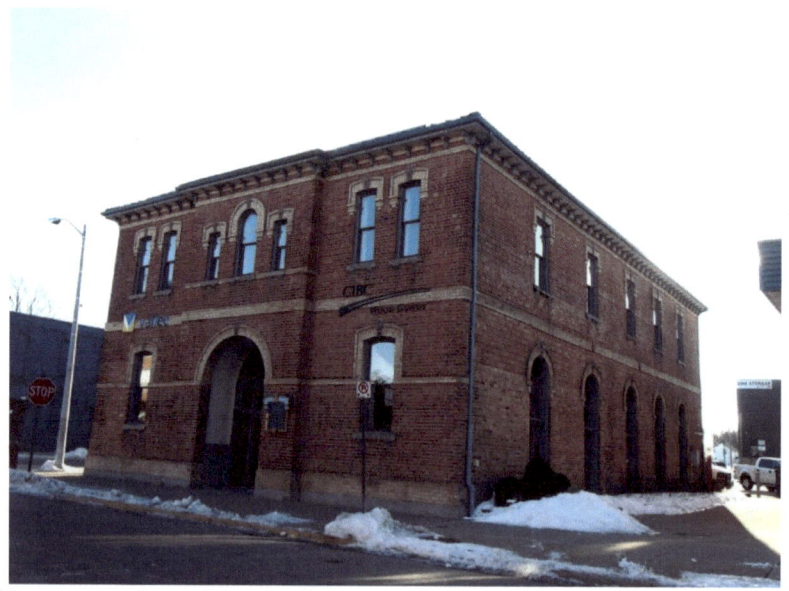

Italianate style – decorative window voussoirs and keystones

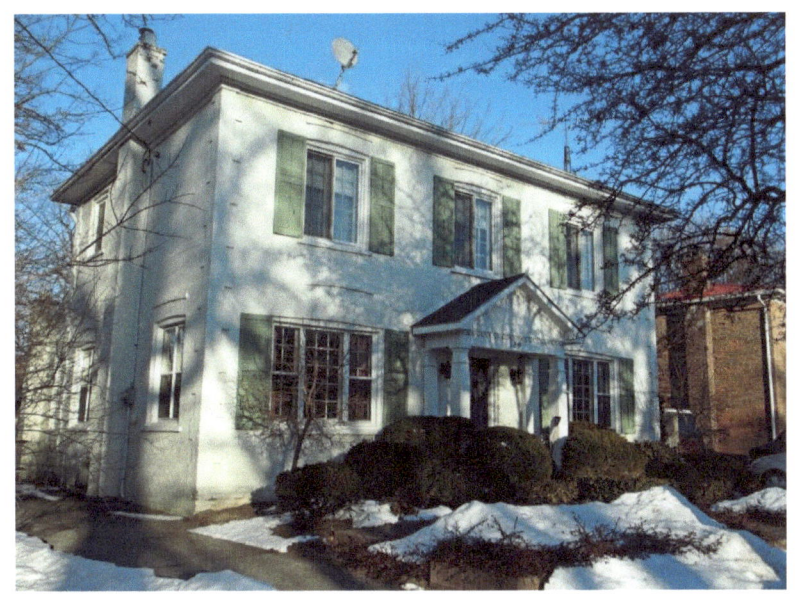

#189 – Georgian style

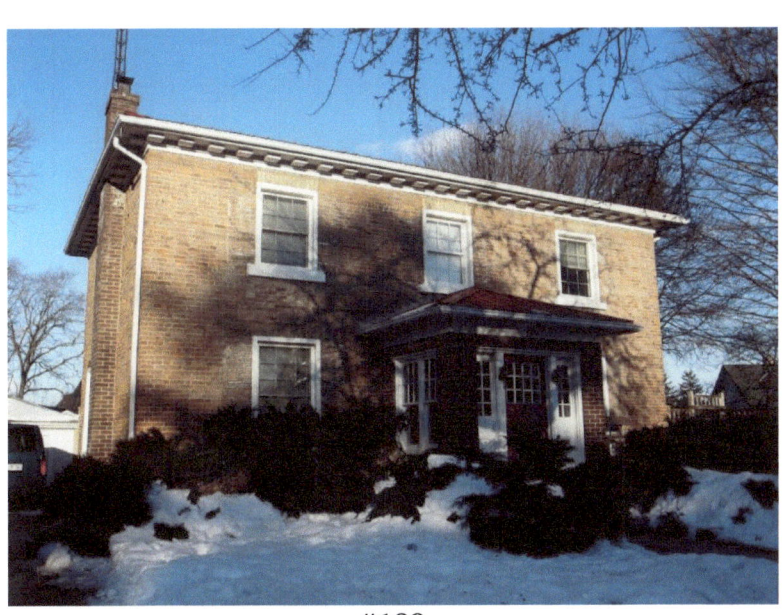

#199

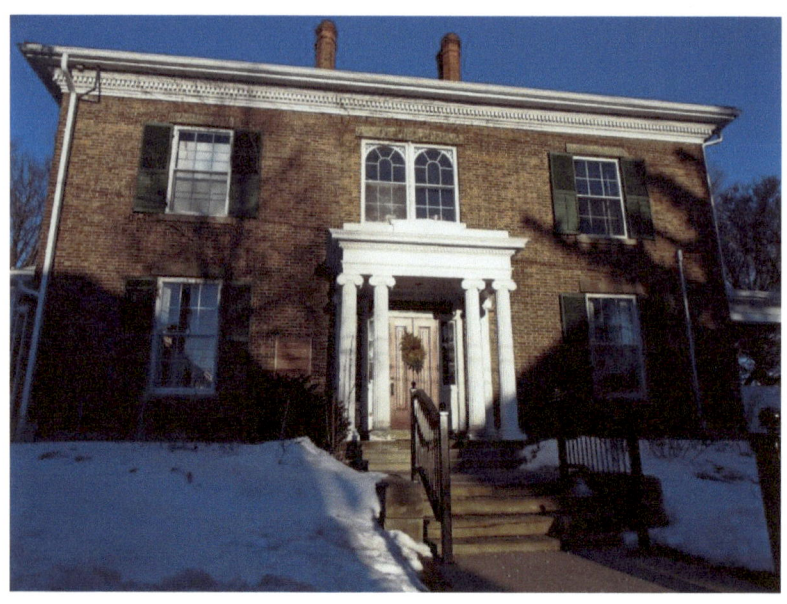

21 Lynnwood Avenue – built in 1850 for Duncan Campbell, banker - Classical Revival style

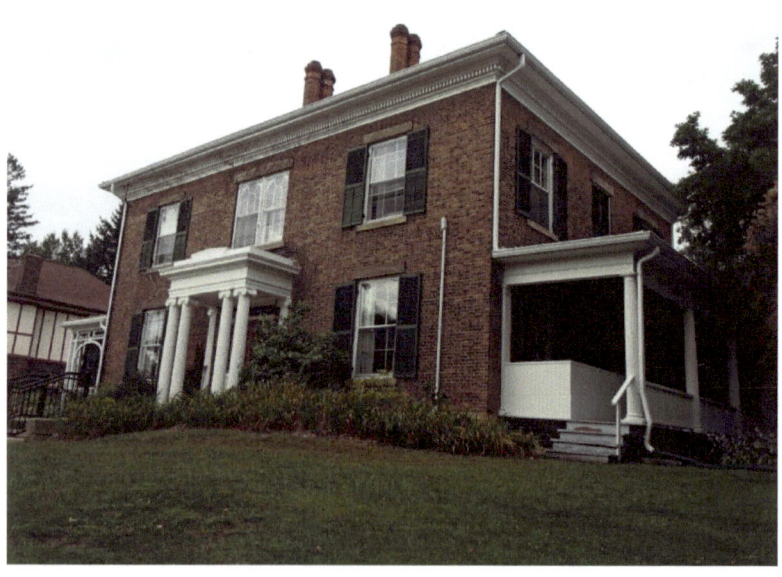

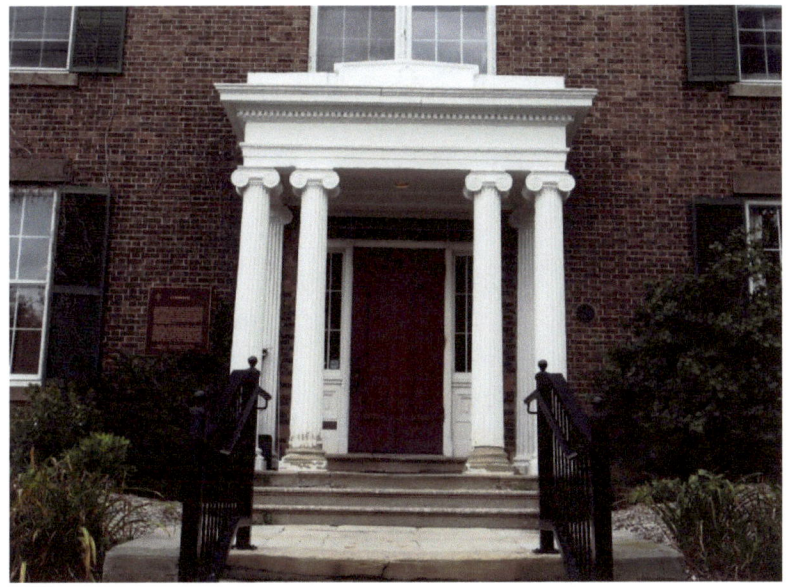

Decorative capitals on top of porch pillars

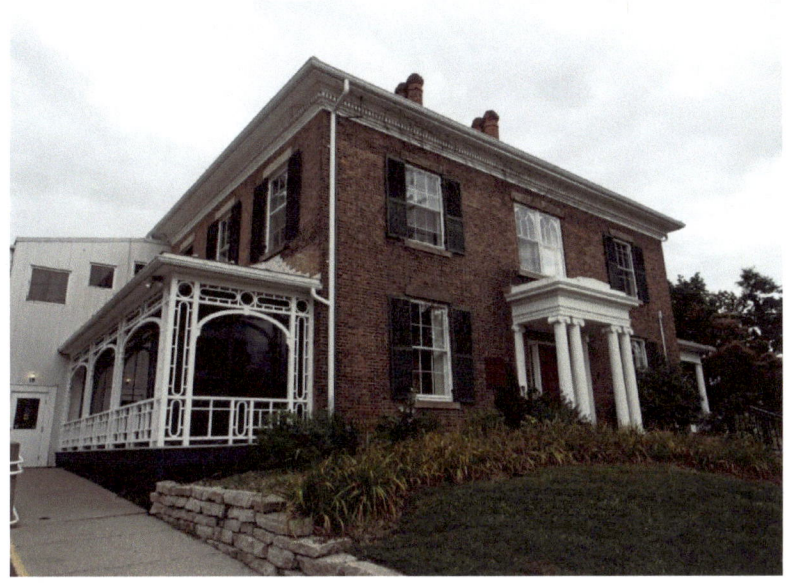

17 Lynnwood Avenue – Italianate style with dormer in attic of hipped roof

22 Lynnwood Avenue – Edwardian style

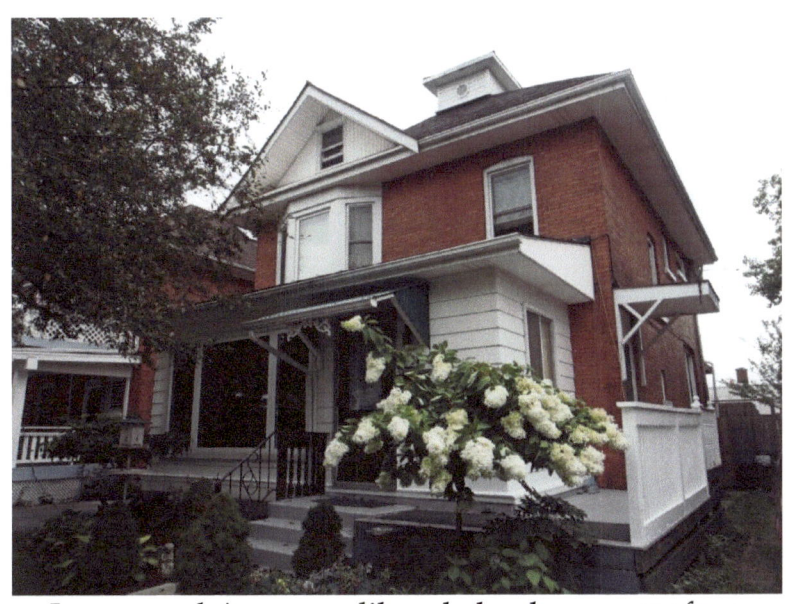

Lynnwood Avenue – like a belvedere on rooftop

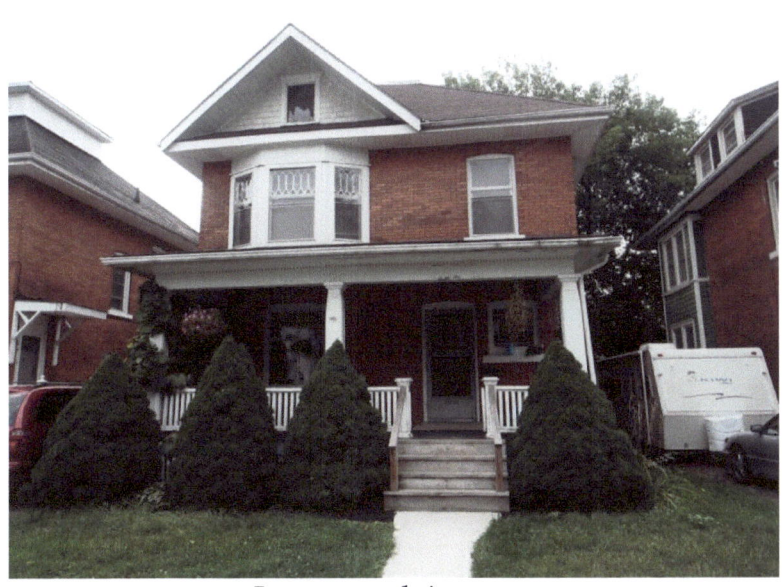

Lynnwood Avenue

40 Lynnwood Avenue

23 Argyle Street – former Simcoe Public Library

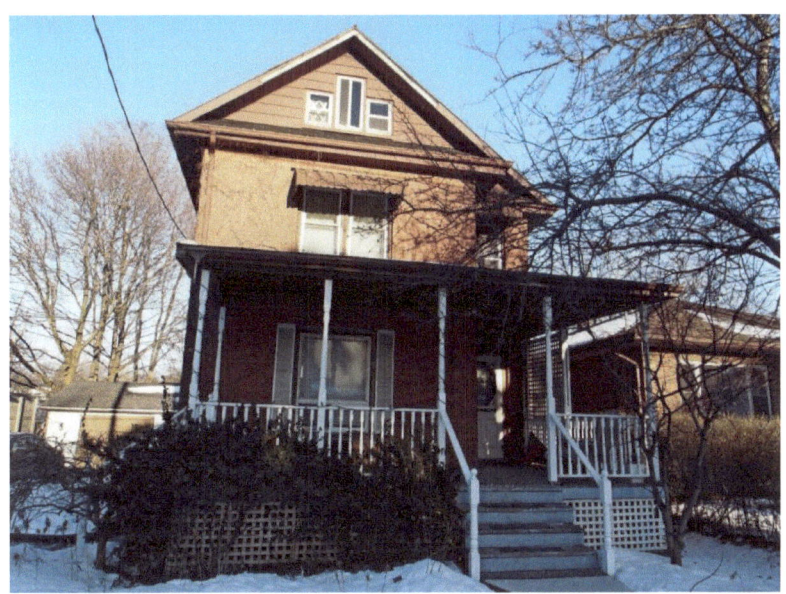

#61 - Edwardian style with Palladian window in gable

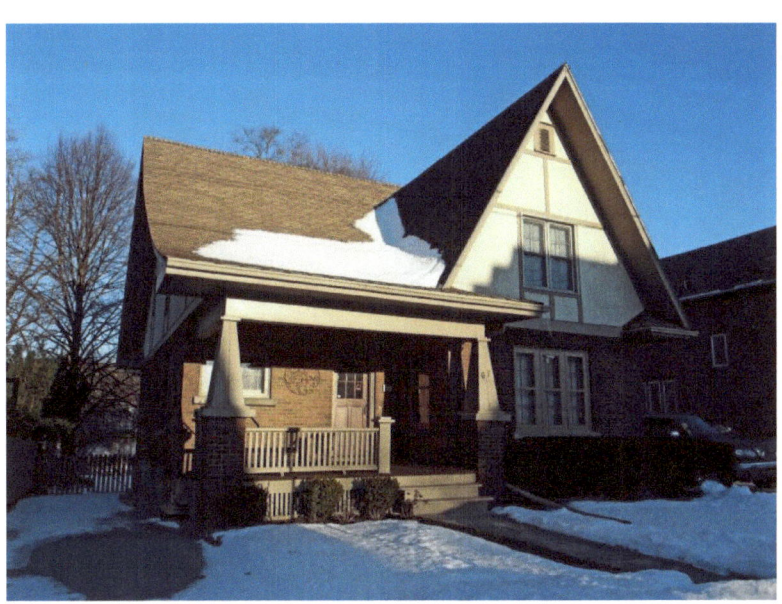

#67 - Gothic/Tudor style

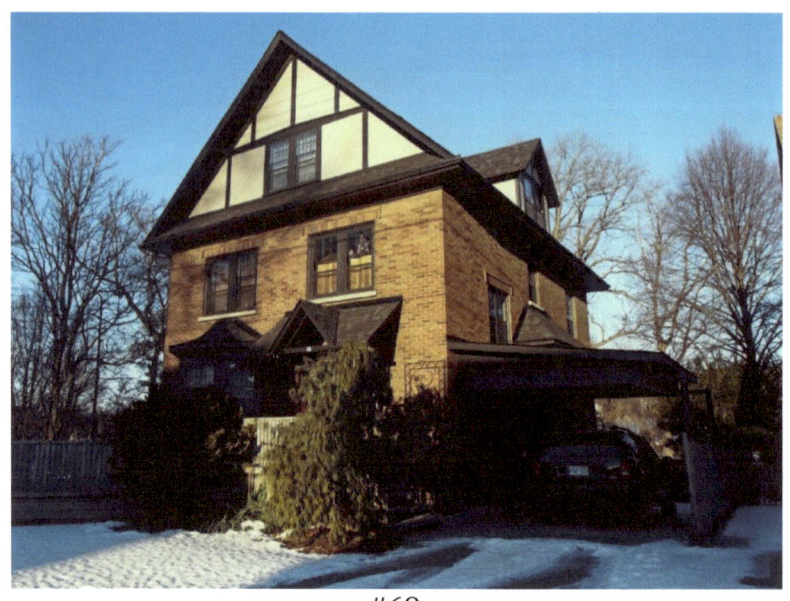
#69

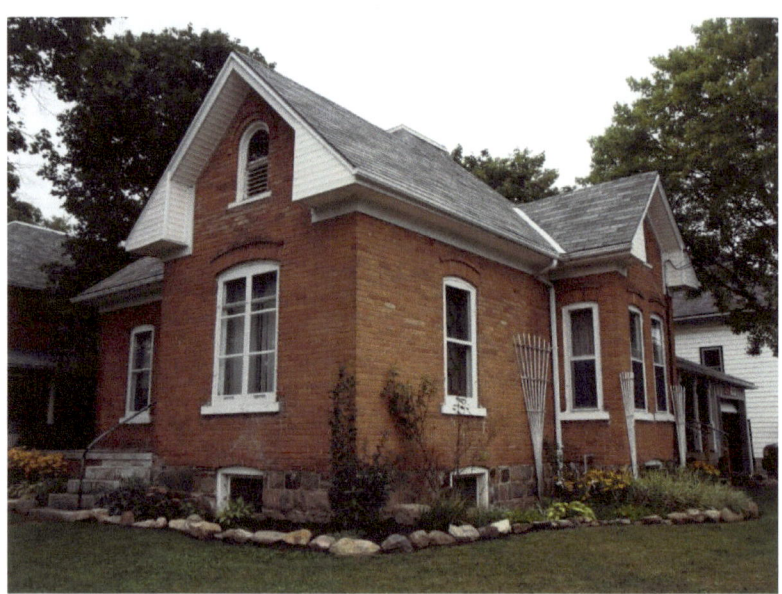
Talbot Street – decorative window voussoirs

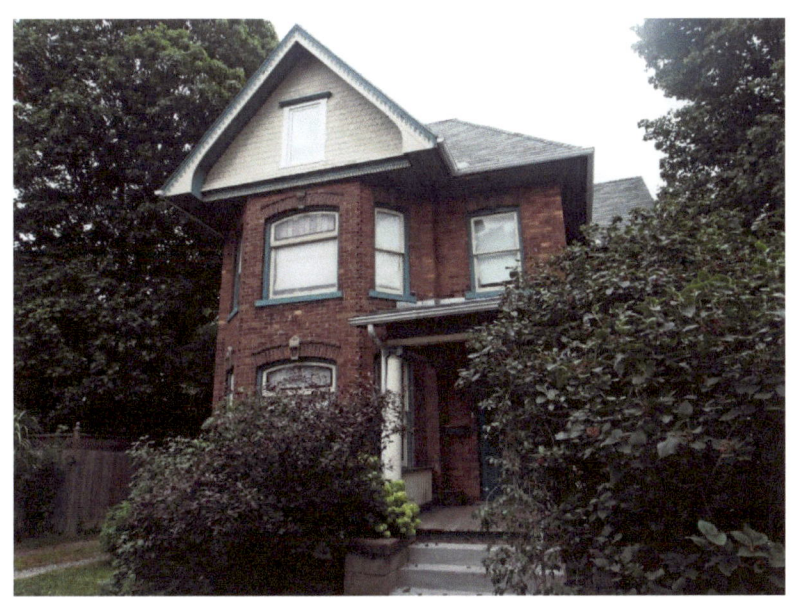

Talbot Street

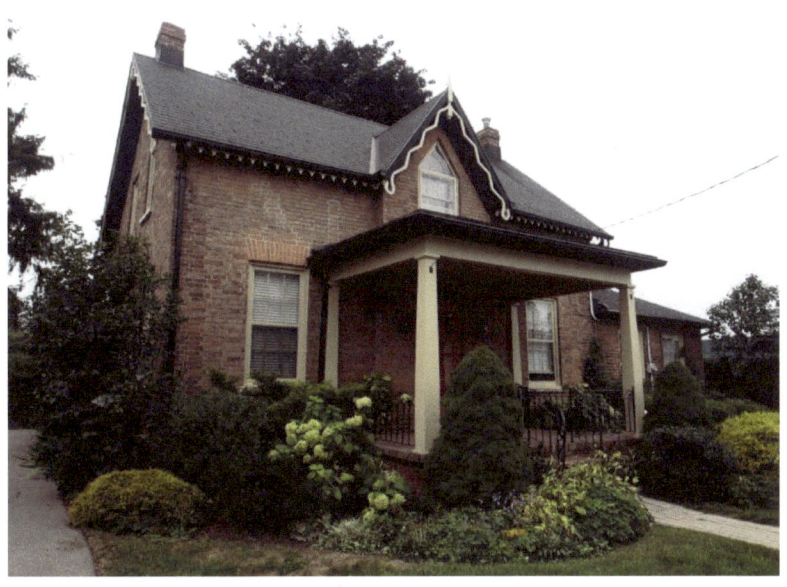

Former church – 30 Talbot Street

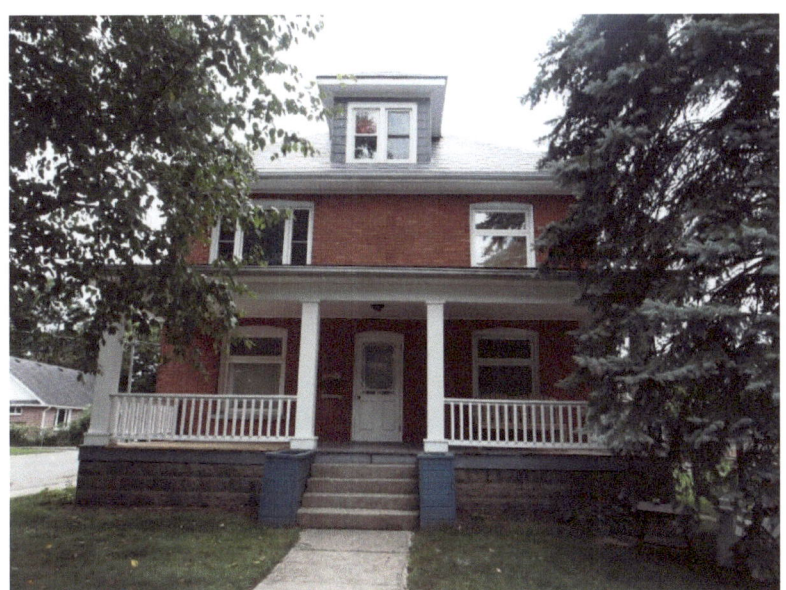

Groff Street – Italianate style with dormer in attic

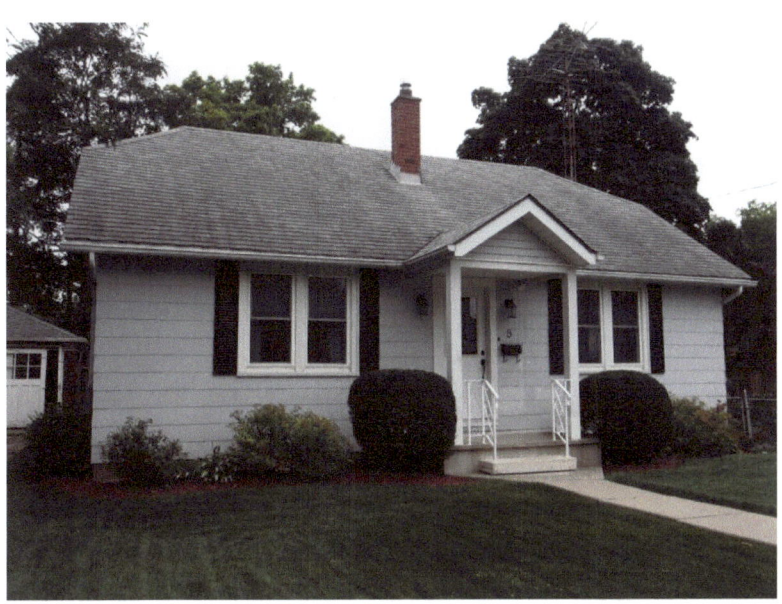

8 Groff Street – Regency Cottage

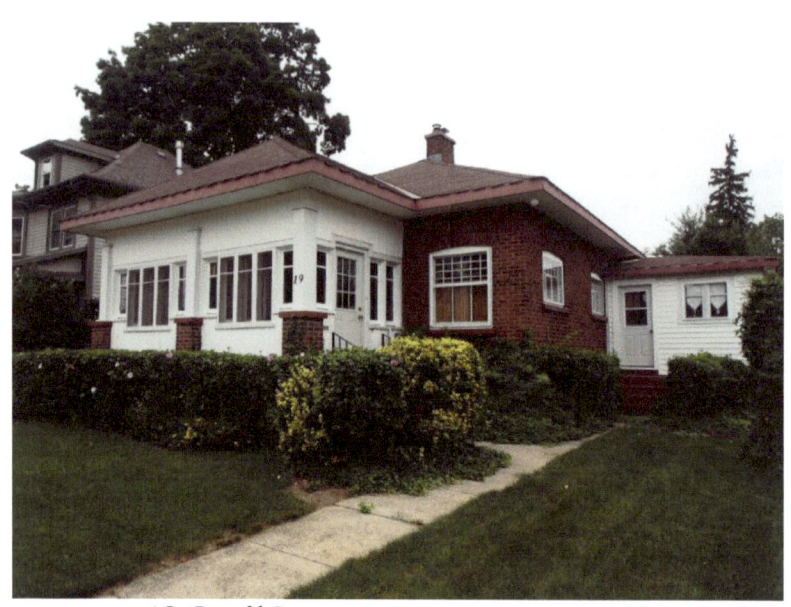

19 Groff Street – one-storey cottage

10 Groff Street – one-storey cottage

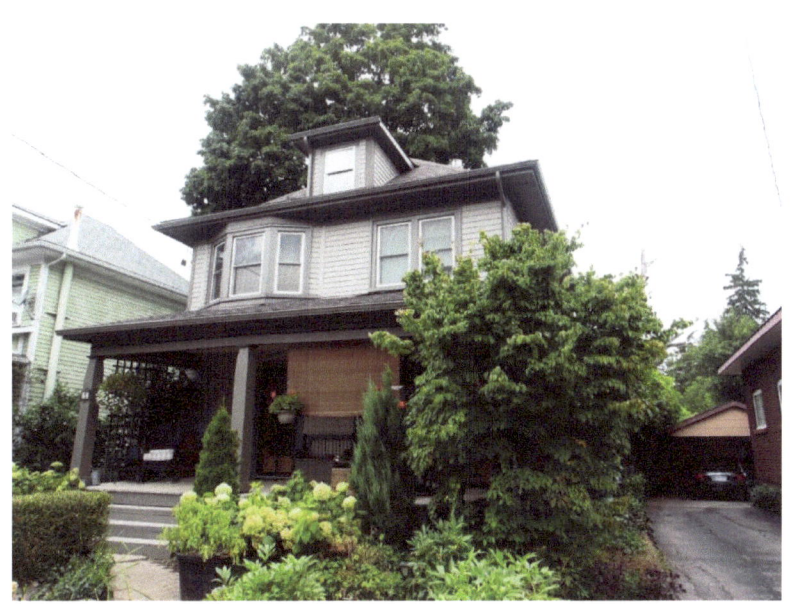

23 Groff Street – dormer in attic of hip roof

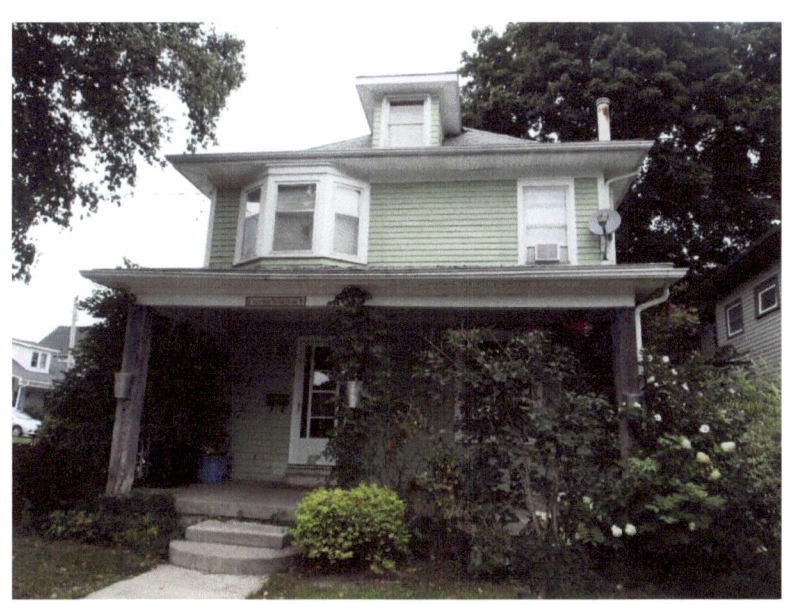

25 Groff Street

102 Brock Street – one-storey cottage

98 Brock Street – one-storey cottage, dormer in roof

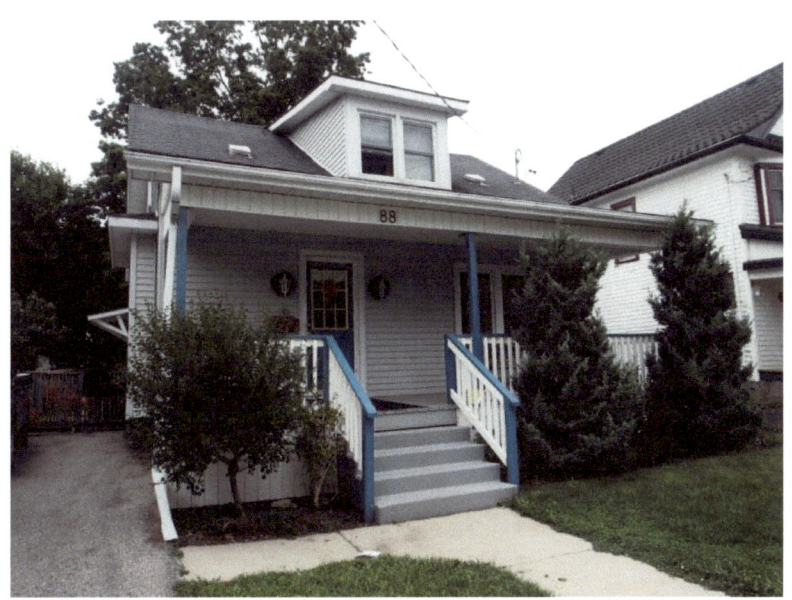

88 Brock Street – one-storey cottage, dormer in roof

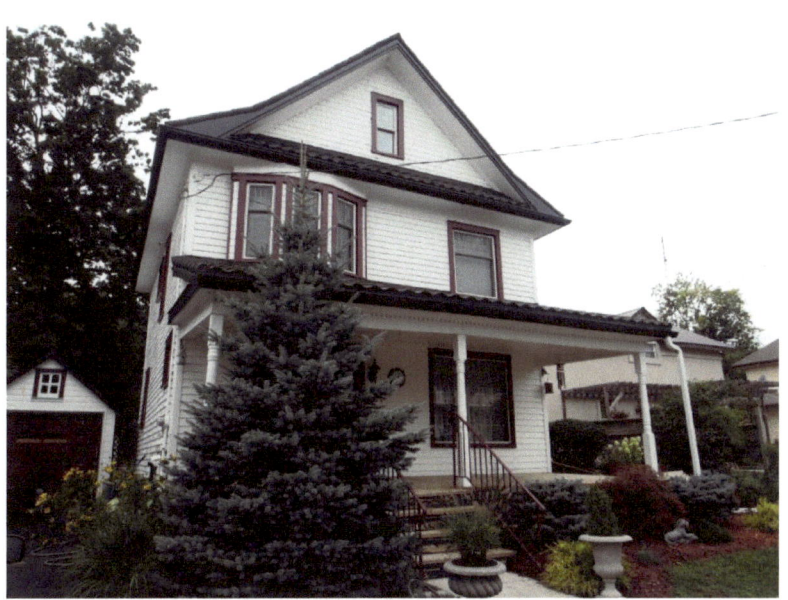

Brock Street – Edwardian style

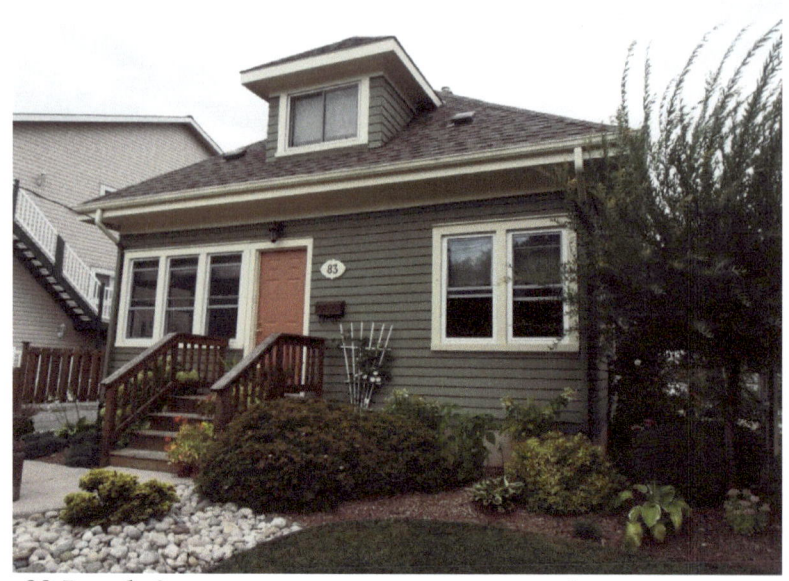

83 Brock Street – one-storey cottage – dormer in attic

79 Brock Street

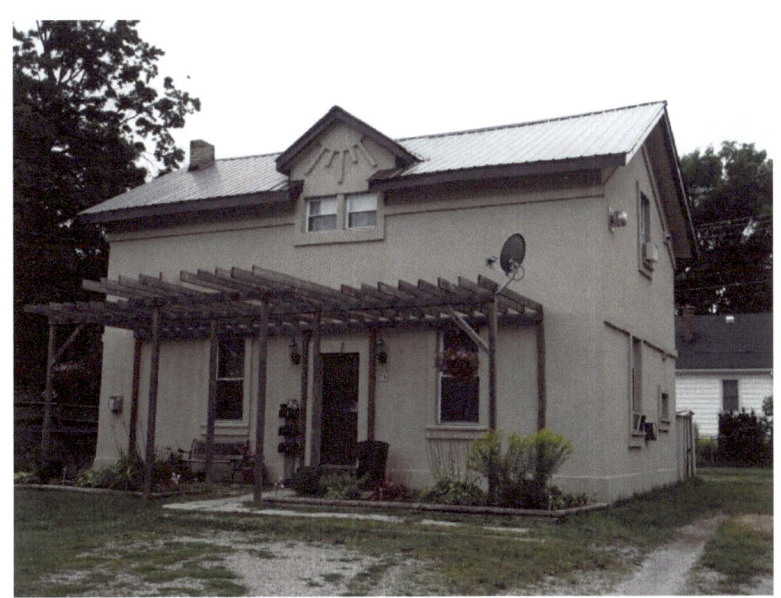

78 Brock Street – Gothic Revival – 1½ storey

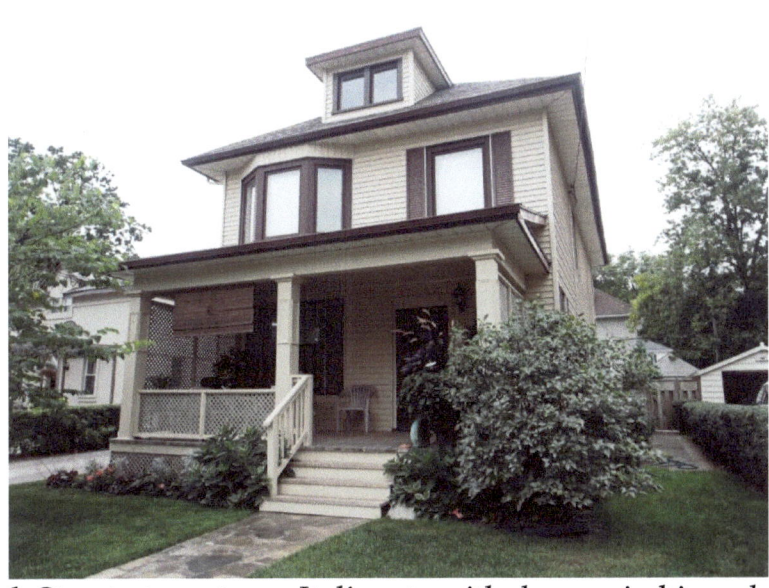

Brock Street - two storey Italianate with dormer in hipped roof

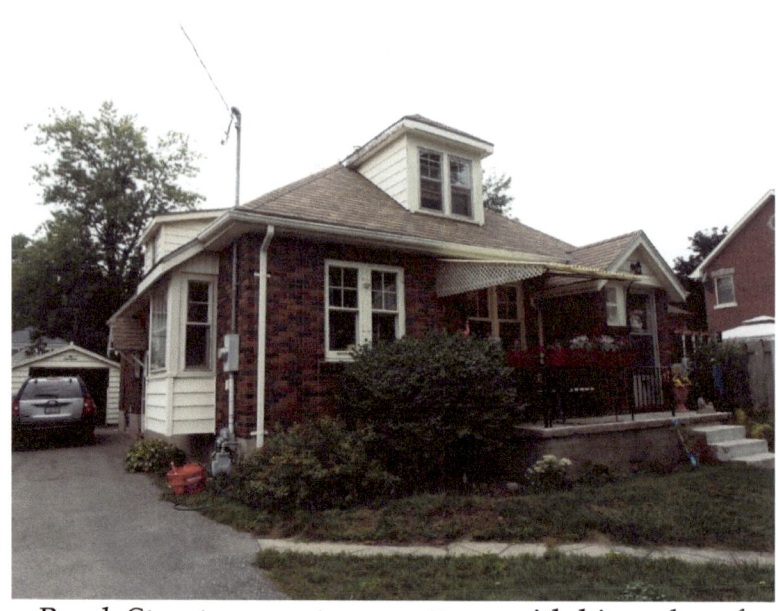

Brock Street – one-storey cottage with hipped roof

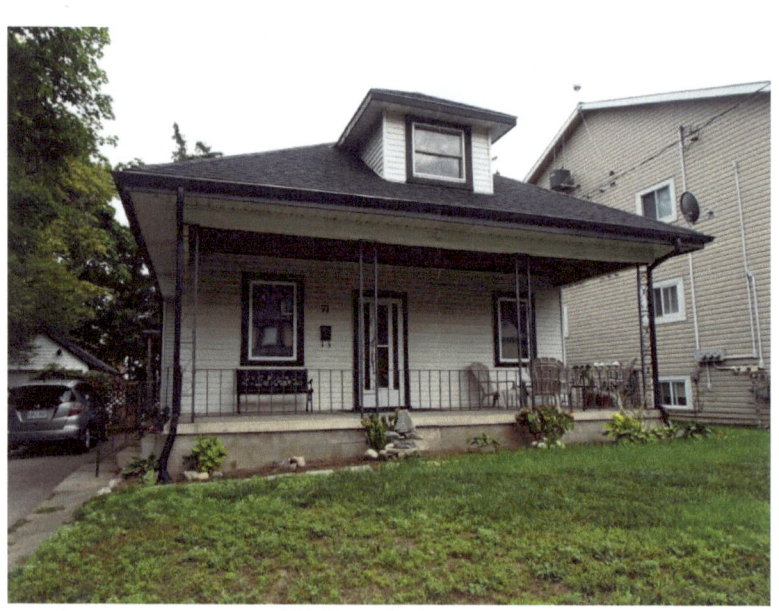

71 Brock Street

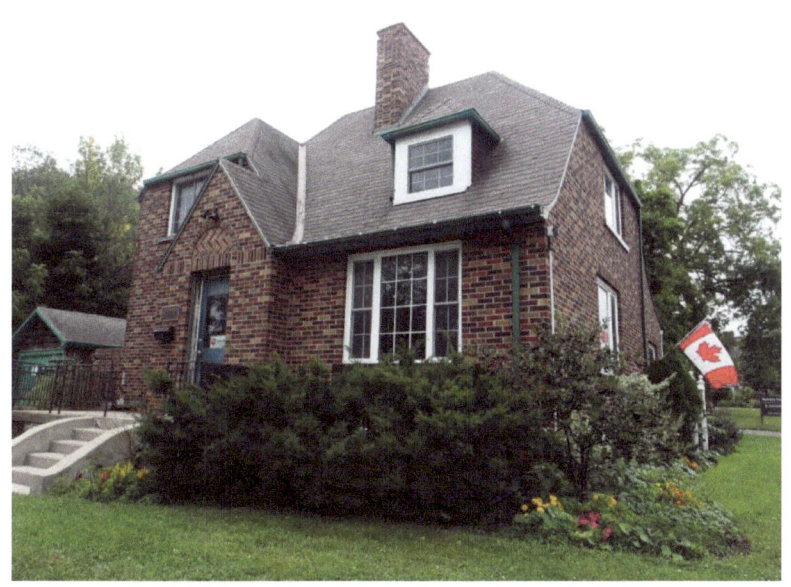

#50 – Pearce House – historical building

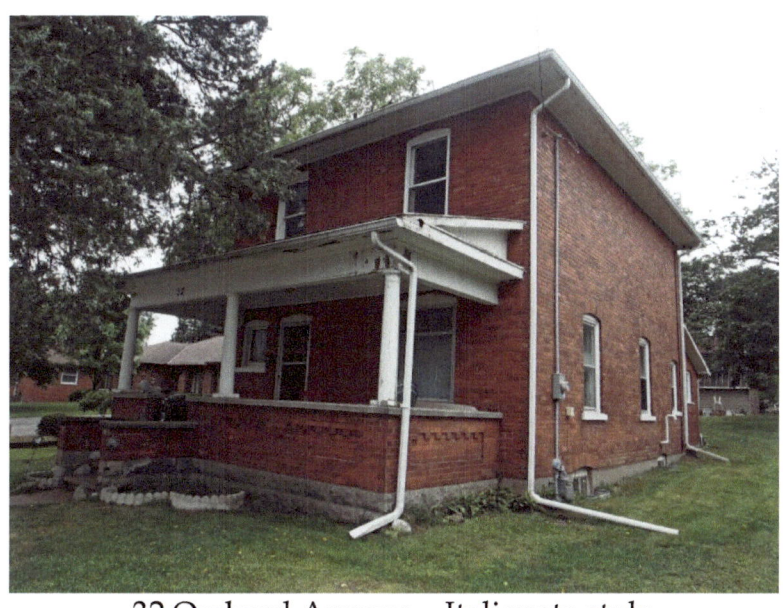

32 Orchard Avenue – Italianate style

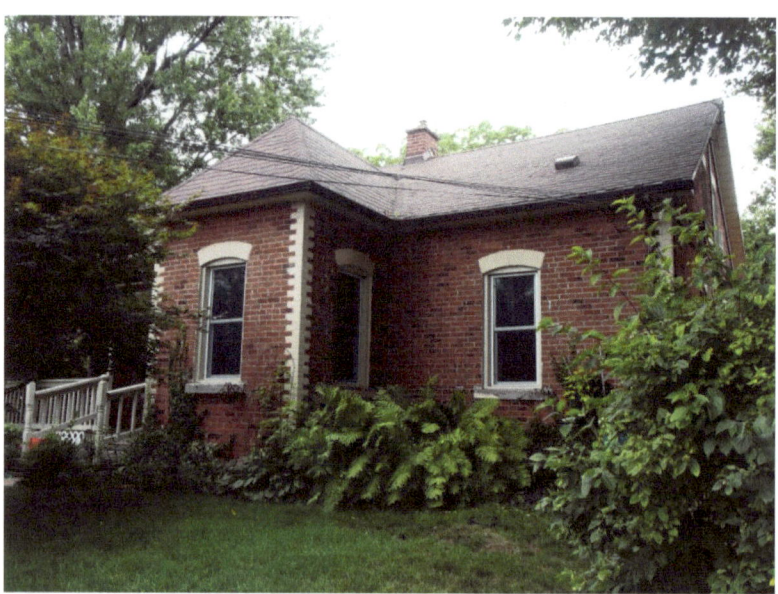

Corner quoins – dichromatic – gabled roof – Gothic

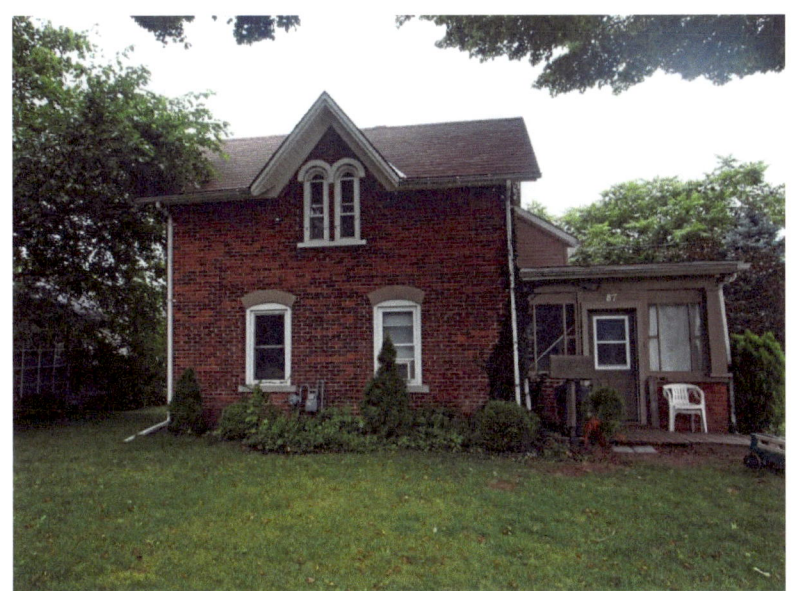

87 Oak Avenue – Gothic Revival – arched window hoods

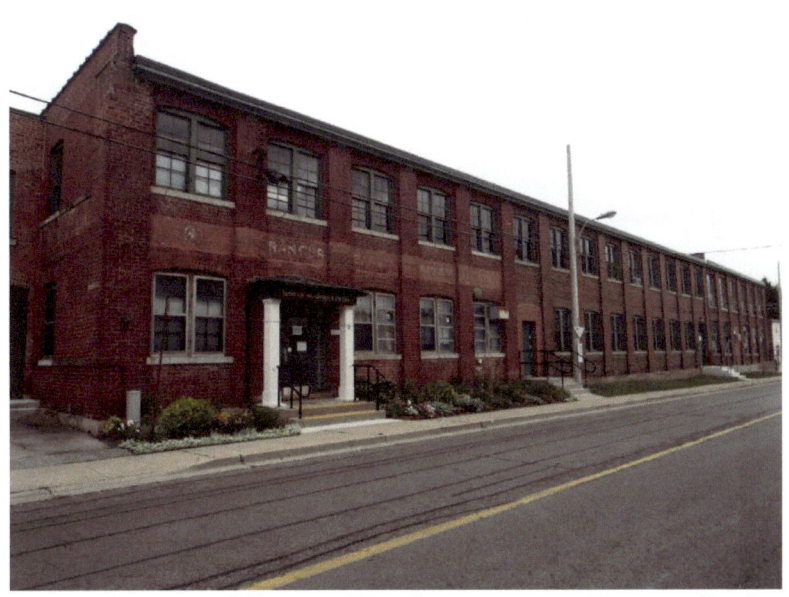

Former factory of Ranger Products – now Simcoe Seniors Centre

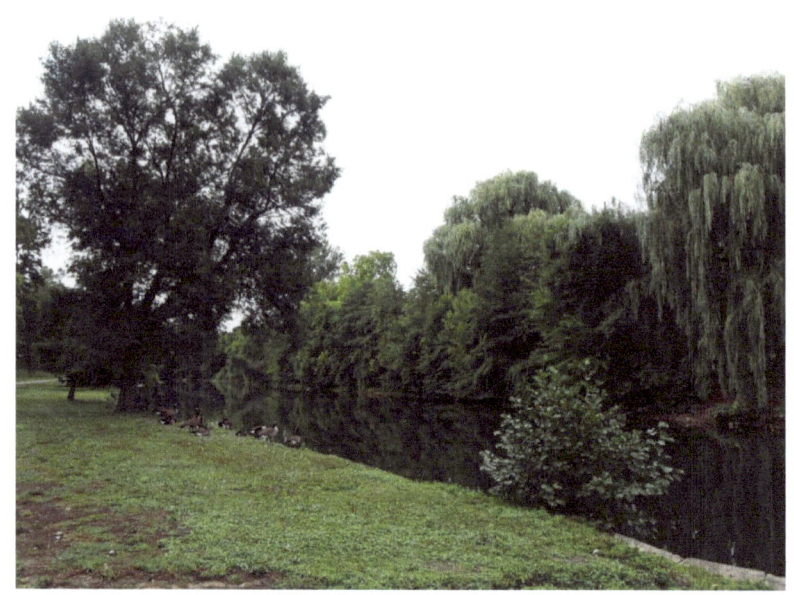
By the river side

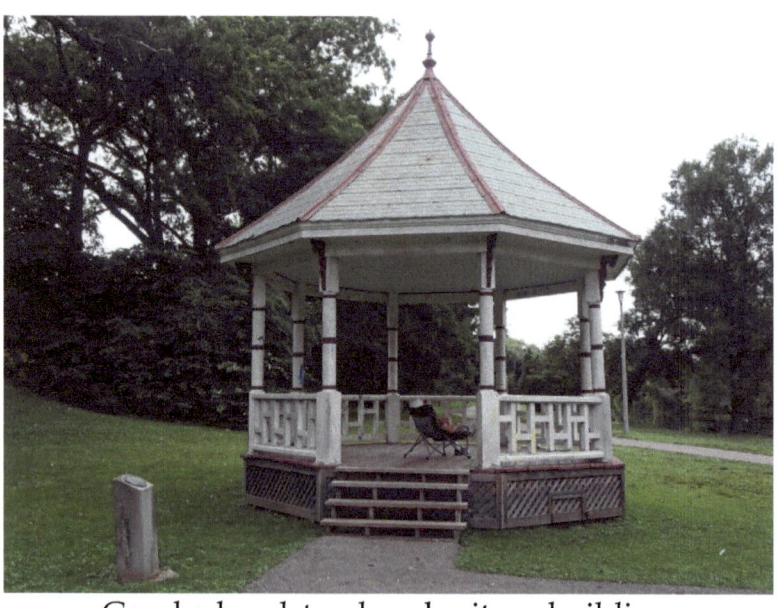
Gazebo bandstand – a heritage building

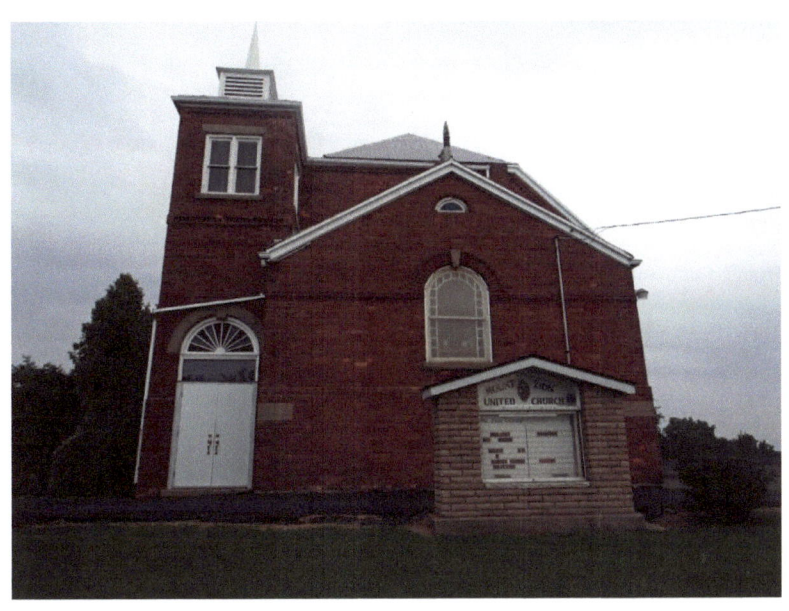

Mount Zion Methodist Church erected in 1902

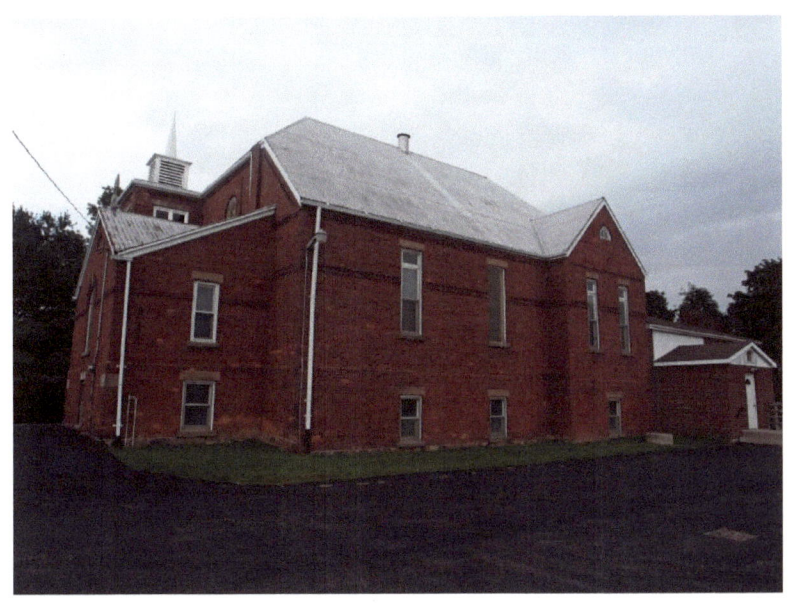

Colborne

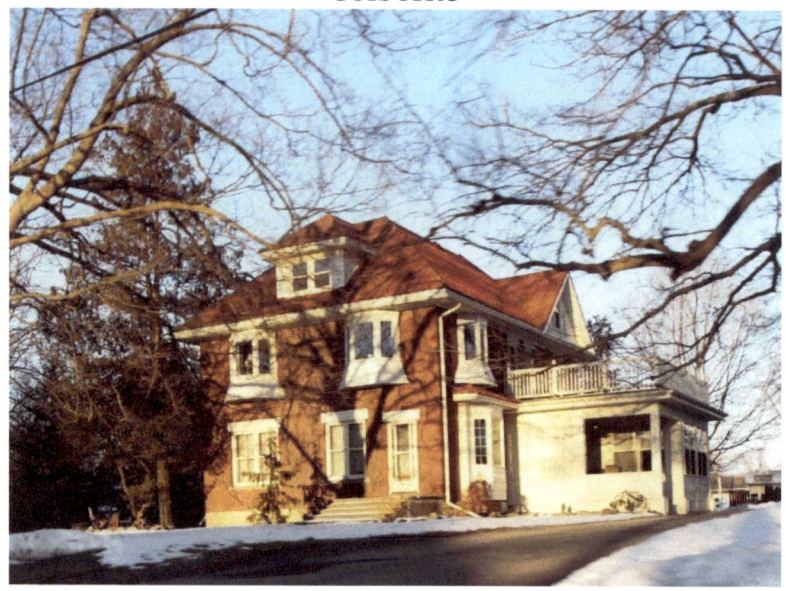

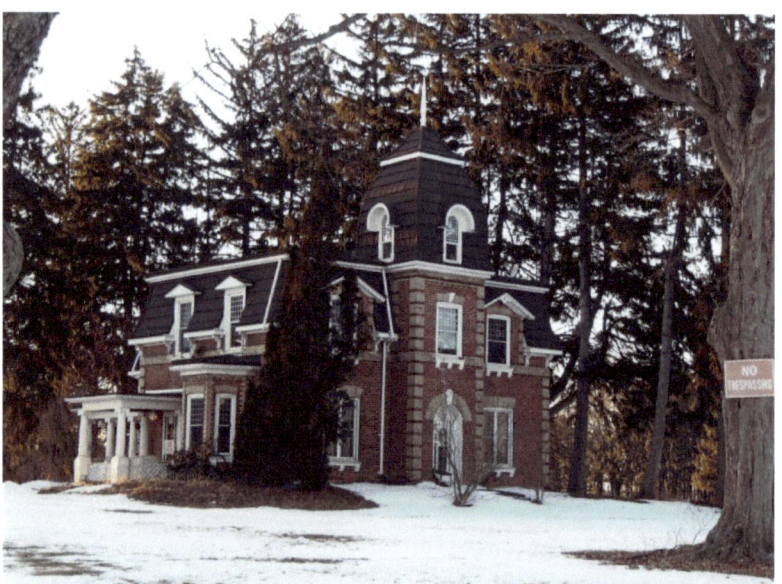

Second Empire style – mansard roof, dichromatic brickwork

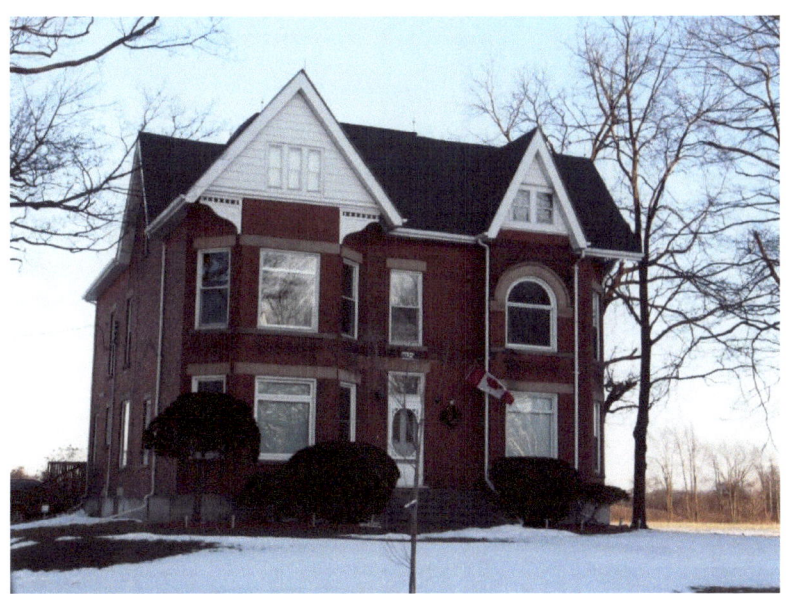

Gothic Revival

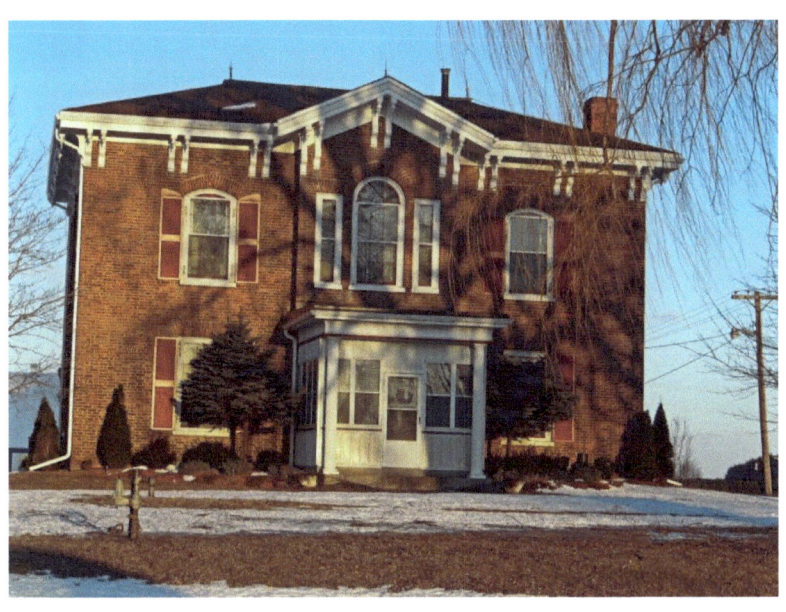

Simcoe is known for its annual Christmas Panorama display of lights.

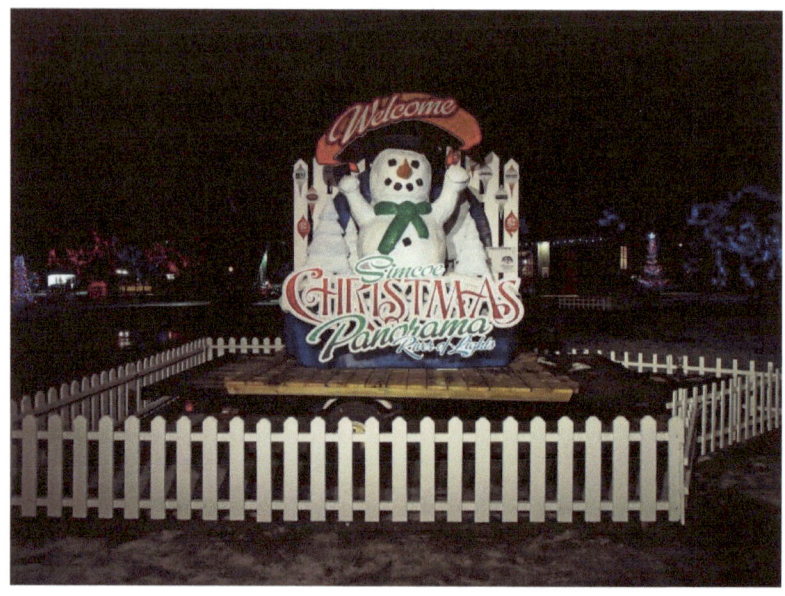

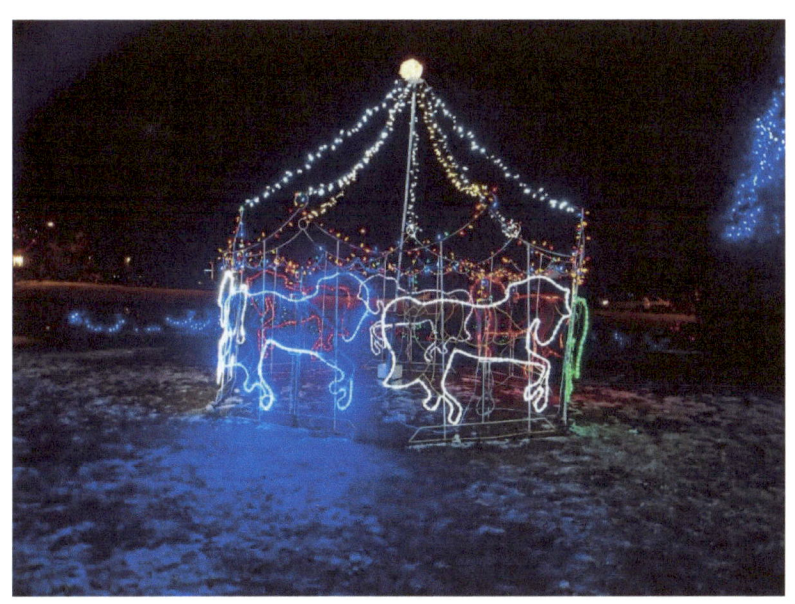

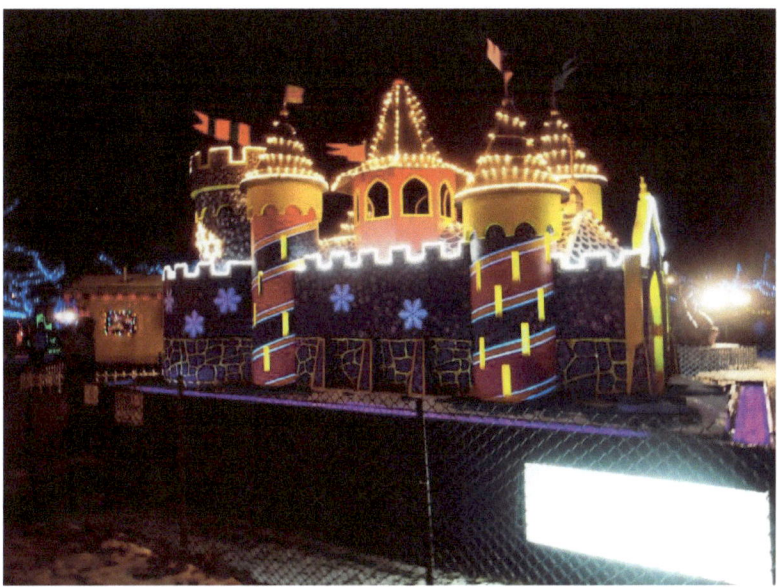

Architectural Terms

Acroterion: an architectural ornament placed on a flat base Example: Norfolk County Court House, Simcoe	
Brackets: a decorative or weight-bearing structural element which forms a right angle with one side against a wall and the other under a projecting surface such as an eave or roof. Example: Norfolk Street, Simcoe	
Buttress: a masonry structure built against or projecting from a wall which serves to support or reinforce the wall. In Canadian architecture, they are sometimes used for decoration. Example: 80 Colborne Street South	
Cornice: originally the wooden overhang of the roof. With the use of stone, brick, iron and steel, the cornice is any projecting shelf at the top of a ceiling or roof. They can be very decorative. Example: 94 Norfolk Street, Simcoe	
Cupola: a small, dome-like structure on top of a building often used to provide a lookout or to admit light and air. Example: 94 Norfolk Street, Simcoe	
Dentil Moulding: an even series of rectangles used as ornamental decoration in cornices.	

Dichromatic brickwork: the use of two colours of brick, tile or slate to decorate a façade. **Dichromatic tile work** Example: Colborne Street, Simcoe	
Dormer: (French for "sleep") a gable end window that pierces through the plane of a sloping roof surface to create usable space in the top floor or attic of a building by adding headroom. Example: 358 Colborne Street	
Frontispiece: a portion of the façade of a building, usually a centred doorway, that is slightly raised from the rest of the building, usually has extensive ornamentation. Frontispieces are usually Classical in design with white columned porches. Example: 400 Colborne Street, Simcoe	
Gable: the triangular portion of a wall between the edges of a sloping roof. Example: 80 Norfolk Street, Simcoe	
Hipped Roof: a roof where all sides slope downwards to the walls with no gables. Example: 384 Colborne Street, Simcoe	

Iron Cresting: A decorative ornament along the top of a roof. Iron cresting was popular in the Baroque era and also in Italianate, Victorian, Second Empire and Queen Anne styles of architecture.	
Keystones and Voussoirs: a voussoir is a wedge-shaped element used in building an arch. A keystone is the central stone that locks all the stones into position, allowing the arch to bear weight. A keystone is often enlarged and embellished.	
Lancet Window: a tall, narrow window with a pointed arch at its top. Example: St. Paul's Presbyterian Church, 95 Lot Street, Simcoe	
Mansard Roof: This style was popularized by Francois Mansart (1598-1666), an accomplished architect of the French Baroque period and especially fashionable during the Second French Empire (1852-1870). This roof is almost flat on the top section, with two slopes on each of its sides with the lower slope at a steeper angle than the upper and having dormer windows. Example: Colborne Street, Simcoe	
Palladian Window: a large window that is divided into three sections with the centre section larger than the two side sections and usually arched. Example: 96 Norfolk Street South	

Quoin: masonry blocks at the corner of a wall, often a decorative feature, usually larger or of a different colour than the rest of the wall. Example: 162 Colborne Street	
Rose Window: a circular window with ornamental tracery radiating from the centre. Example: St. Paul's Presbyterian Church, 95 Lot Street	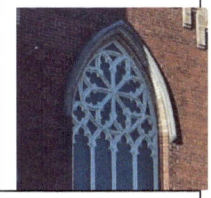
Vergeboards: also called bargeboards – hang from the projecting end of a roof and are often elaborately carved and ornamented. Example: Talbot Street	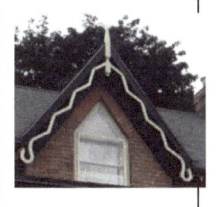

Simcoe's Building Styles

Edwardian, 1900-1930 – This style bridges the ornate and elaborate styles of the Victorian era and the simplified styles of the 20th century. Balanced facades, simple roof lines, dormer windows, large front porches, and smooth brick surfaces are its characteristics. Example: 62 Lynwood Drive, Simcoe	
Georgian, before 1860 – This style began with the British King Georges in the 18th century. These buildings have balanced facades around a central door, medium-pitched gable roofs, and small paned windows. Example: 109 Norfolk Street South, Simcoe	
Regency Cottage, 1830-1860 – This style originated in England in 1815 and spread to Ontario later in the 19th century as British officers retired to Canada. It is a modest one-storey house with a low-pitched hip roof and has a symmetrical front façade. Example: 8 Groff Street	
Gothic Revival, 1830-1890 – These decorative buildings have sharply-pitched gables with highly detailed vergeboards, pointed-arch window openings, and dichromatic brickwork. It is a common style in Ontario. Example: #1025 - Colborne	

Italianate, 1850-1900 – It has wide-bracketed eaves, belvederes, wrap-around verandahs. Example: 358 Colborne Street, Simcoe	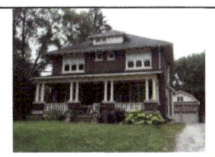
Second Empire, 1860-1880 – The mansard roof is the most noteworthy feature of this style and is evidence of the French origins. Projecting central towers and one or two-storey bays can also be present. Example: 217 Colborne Street, Simcoe	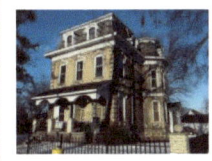
Queen Anne, 1885-1900 – This style is distinguished by an irregular outline featuring a combination of an offset tower, broad gables, projecting two-storey bays, verandahs, multi-sloped roofs, and tall, decorative chimneys. A mixture of brick and wood is common. Windows often have one large single-paned bottom sash and small panes in the upper sash. Example: 364 Colborne Street, Simcoe	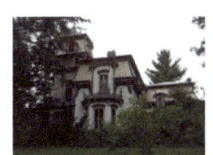
Tudor Revival – exposed timbers with stucco infill, multi-paned windows. Example: 15 Brant Road North, Simcoe	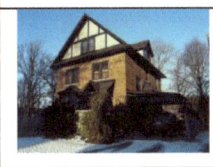

www.ingramcontent.com/pod-product-compliance
Lightning Source LLC
Chambersburg PA
CBHW040836180526
45159CB00001B/208